BEAUTIFUL GOATS

portraits of
CLASSIC BREEDS

FELICITY STOCKWELL
photographed by ANDREW PERRIS

IVY PRESS

This edition published in the UK and North America in 2020 by

Ivy Press
An imprint of the Quarto Group
The Old Brewery, 6 Blundell Street
London N7 9BH, United Kingdom
T (0)20 7700 6700
www.QuartoKnows.com

First published in the UK in 2014

© 2017 Quarto Publishing plc

British Library Cataloguing-in-Publication Data
A catalogue record for this book is available from the British Library

ISBN: 978-1-78240-942-7

This book was conceived, designed and produced by

Ivy Press
58 West Street, Brighton BN1 2RA, United Kingdom

Creative Director **Peter Bridgewater**
Publisher **Susan Kelly**
Art Director **Wayne Blades**
Senior Editors **Jayne Ansell & Jacqui Sayers**
Designer **Ginny Zeal**
Photographer **Andrew Perris**
Illustrator **David Anstey**

Printed in China

10 9 8 7 6 5 4 3 2 1

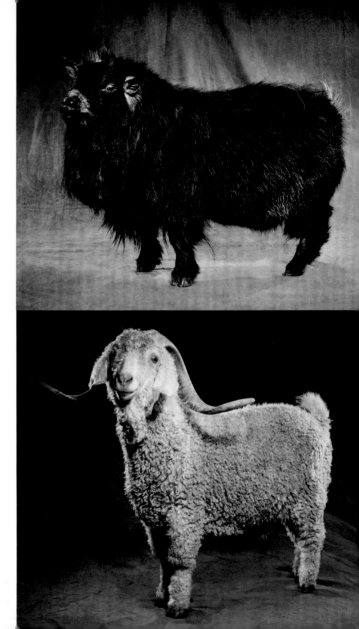

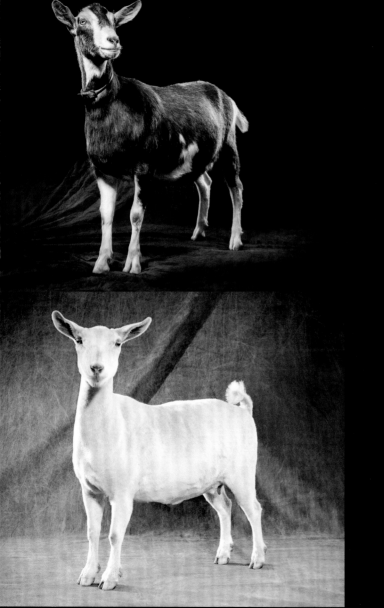

CONTENTS

Introduction 6

THE GOATS *14*

REPORTAGE *96*

Glossary 110

Shows & Associations 110

Index 112

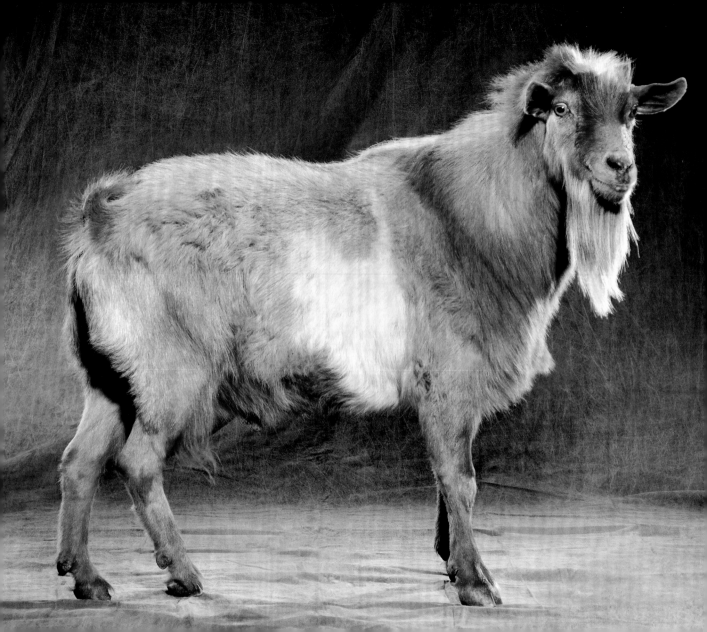

INTRODUCTION

GOATS HAVE BEEN DOMESTICATED BY HUMANS around the world for thousands of years for their milk, meat, skins, and fiber. From the native tribes living on the African plains, in the Far East, or traveling across Middle Eastern deserts to today's large-scale commercial milk, meat, and dairy industry, the goat has always found its place in human habitation. Even today, many cultures still depend on this diminutive but prolific provider of food, fleece, and skins for their livelihood. For a farmer, the goat is the ultimate dairy animal, requiring a proportionately small amount of food and accommodation.

The range of breeds and colors is endless with a diversity of uses that no other ruminant can provide. This includes the Angora goat, prized for its valuable mohair fleece, and the Cashmere, which provides cashmere wool—the most expensive fiber in the world—through to the meat-specific Boer breeds and the Alpine breeds developed in Europe for commercial milk production.

Intelligent and inquisitive with an athleticism that can both entertain and amaze, the domestic goat can interact with its human companions on a similar level of trainability and devotion as a dog.

The goat is also prized and adored both in the show ring and as a domestic pet. "Burgan," an Arabian Najdi male stud—one of the most revered breeds in the world—was valued at 450,000 riyals (approximately $95,700) and his sons have been sold for sums in excess of $19,000. Sales of this breed take place in Riyadh, Saudi Arabia, following a goat "beauty" contest attended by thousands of people.

For goat keepers who enjoy showing their animals, much time and effort is expended on keeping the goats in perfect condition. This is clearly demonstrated by the beautiful images in this book, which have been captured by award-winning photographer Andrew Perris at goat breed shows and farms. His studio portraits are complemented by detailed text on each breed, describing its origins, characteristics, and uses. The result is a celebration of the diversity of goat breeds, a testament to their importance in our world, and a chance to admire their truly extraordinary character.

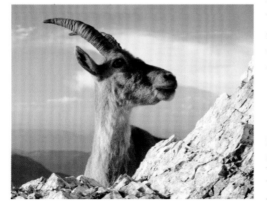

Left: The brownish-gray mountain goat climbs rocky slopes to graze at high altitudes above the Alpine forest.

HISTORY, DOMESTICATION & CULTURAL SIGNIFICANCE

FROM BEING ONE OF THE EARLIEST TYPES OF live-stock kept in domestication by primitive human civilizations at least 10,000 years ago, there are now in excess of 1,400 million goats worldwide. The main spread occurred during the 19th century, largely as a result of the expansion in ships travelling around the globe. These ships would take goats aboard as milk and meat providers and they would be turned loose at the journey's end, often on remote islands. This would allow them to naturalize in their new environment to be later captured and farmed.

Domestication of goats has been facilitated by their size and their being relatively easy to capture. They adapt quickly to captivity and form an attachment to their human companions. As they are intelligent animals, it is possible that they realized humans could offer protection from natural predation.

Minimal food demands allow goats to survive harsh conditions and food shortages where other animals would perish. Their longevity of life and ability to breed at an early age, producing their own offspring before they are a year old in many cases, has also made them an obvious choice for food production.

Goats are revered by many cultures, appearing in the Western astrological zodiac and those of China, Japan and Taiwan. In Scandinavia, goats are considered the protector of Christmas and also the God Thor, and in Europe they are associated with the God Jupiter. Many important works of art feature goats as a symbol of beauty, strength, energy and tractability.

In religious terms, the goat is considered a clean animal and so its meat can be eaten by all cultures. Somewhat unfairly, the billy goat has often been associated with Satan – this is almost certainly attributed to his somewhat lusty outlook on life in his search for a partner!

In the UK and the US, regimental goats have been a part of the armed forces for more than 150 years with every American regimental goat known as "Bill the Goat" and every UK equivalent known as "William Windsor." The current William is from a cherished and uninterrupted Kashmir breed line given to Queen Victoria in 1837 by the Shah of Persia.

Left: Like sheep, goats prefer to travel as a herd, which was a key factor in their early domestication.

MEAT & DAIRY

DESPITE THE MASSIVE DISTRIBUTION OF GOATS worldwide, goats' milk accounts for only a little over 2% of milk consumption, even though in Asia the annual milk production is in excess of 4 million metric tons. Conversely, goat meat is the most widely eaten of all animal flesh in the regions of the world where the species is most prolific.

Goat meat is easily and quickly produced and has a very low fat to meat ratio and lightweight bones, making it a very thrifty and high-quality source of protein. Both iron and energy content are also very high in comparison to most other meats. In many cultures there is not a single piece of a goat carcass that goes to waste—horns and hooves are utilized for clothing and tent fastenings, horn is used to create musical instruments and toys, and skins are used for clothing, shelter, and water containers.

Cheese making is a traditional art that was originally developed to preserve milk and provide staple food for the nomadic goat herders of ancient civilizations. In the Western world, goats' cheese was once considered a gourmet product, but nowadays it is seen as a natural choice for a low fat and extremely tasty alternative to cows' milk cheeses, and supply and

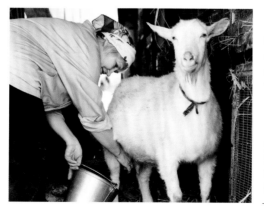

demand has reduced the price to make it more affordable. Contrary to common belief, there is no regional cheese that cannot be made from goats' milk, including hard cheddar-style cheeses and veined "blue" cheeses.

Goats' milk consumption is also increasing as many people with lactose intolerance find they can cope with the smaller fat globules within goats' milk. Yogurt and ice cream made from goats' milk are becoming extremely popular and large-scale goat farms with fully automated milking parlors are now becoming commonplace in most cultures.

The farming of goats for the provision of meat, particularly the Boer, is increasing as demand rises. Goat meat is still difficult to obtain in Western cultures but, as the world's food resources are further pressurized with the growth in our population, the goat, with its natural resistance to many of the modern diseases that compromise cattle and sheep, will very likely become a popular alternative.

Left: Goats' milk is becoming increasingly popular and is used to make cheese, yogurt, soap, and pharmaceuticals.

FIBER, SKIN & TEXTILES

MORE WIDELY USED THAN IS OFTEN APPRECIATED, fiber and skins from goats figure in our daily lives in so many ways. That "Mongolian lamb" collar and cuffs on your favorite coat and the gorgeous, lustrous fiber known as mohair are all in fact from the Angora goat. This breed, kept worldwide, has its origins in Turkey where it remains as a wild goat even today.

Mohair is known as "the diamond fiber" for its radiance and ability to reflect light, creating a stunning fabric for clothing and home furnishings. Even conveyor belts in factories and grocery stores have an element of mohair in them, which helps them to run smoothly.

The first and second shearings from a young goat have the greatest softness and luster so are highly valued for textiles. As the animal ages, the fiber has a coarser texture and this is then used in commercial applications where the fiber quality is less important. Each Angora goat is capable of providing 6.6 to 13.2 lb (3 to 6 kg) of shorn fiber a year, which, when spun, will only produce on average 4.4 to 11 lb (2 to 5 kg) of usable yarn, giving it a very high value.

Cashmere or Cashgora goats produce cashmere wool, which is used to make wonderfully soft fabrics and knitwear. The wool from the Cashgora is lower quality than the Cashmere and is therefore less valuable. The amount produced from each animal is quite small—often no more than around 1.1 lb (500 g) per year from two combings (though variations due to climate and nutrition occur)—making it arguably the most highly priced natural animal fiber in the world.

Skins from many breeds are used for a myriad of purposes, from floor rugs, cushions, and coats to fashion trimmings, gloves, and bags. In nomadic cultures, goat skins are used for making water carriers, cheese-making receptacles, milk receptacles, fire bellows, blankets, clothing, and shelters.

Kid leather is one of the softest and most workable fine grain leathers available and comes from animals under 18 months of age. Leather from older animals is more hard wearing and may be used for coats, jackets, and bags, and for the production of "chamois" leathers commonly used for cleaning glass and fine paint finishes.

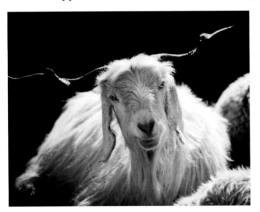

Left: Cashmere comes from the soft undercoat of the double fleece of goats bred to produce this luxury wool.

PETS & RECREATION

As an agricultural animal that could also be classified as a pet, goats are certainly one of the most rewarding creatures you will ever find. Reasons for keeping them are almost too many to list.

They are funny, entertaining, endearing, attractive, and as trainable as the family dog, with a similar life expectancy, although retrieving sticks in the park may be a step too far!

Tiny Pygmy goats can be kept in a small garden and even the larger dairy breeds can be quite easily accommodated on an average plot, providing they are kept clean, attended to twice a day, and have access to clean, fresh water at all times. Goats are great escape artists, so secure and safe accommodation is vital to avoid conflict with your neighbors and their vegetable patch, and possibly any poisonous plants.

Goats are herd animals and as such should be kept with other caprine companions, although there are many that have lived long, happy, and productive lives with just their human friends.

Many goat keepers have pet goats simply as companion animals with no other purpose, but goats will provide you with a plentiful source of fresh milk and its derivatives, if required.

An increasing number of owners also enjoy breeding and selling the offspring, or showing goats, where at shows friendships can be forged between other like-minded individuals. Local and national groups and breed societies offer support and information to both new and established goat keepers at all levels.

Recreationally, there is an ever growing group of people, particularly in the US, who are keeping harness goats. These goats are trained to be driven to purpose-built traps, carriages, and coaches as single, tandem, or up to "eight in hand" rigs. Generally, larger wethered (neutered) males are used for this purpose. This is not a new idea—in Victorian times it was commonplace to see driven goats in seaside resorts giving rides to tourists, and many middle-class families in those times had a goat cart at home for their children to use.

Whether they are kept as pets, companions, or food providers, goats are officially agricultural animals and are subject to national agricultural rules and regulations.

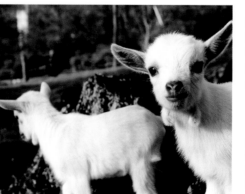

Left: The Pygmy goat is small, hardy, friendly, intelligent, and self-exercising, making it an ideal pet, but it needs proper care.

RARE & ENDANGERED BREEDS

DESPITE THE WORLDWIDE AND PROLIFIC SPREAD of goats, some of the original early breed types are now being lost and much is being done by individuals and groups to ensure the survival of these valued breed lines.

In the UK, the Rare Breeds Survival Trust (RBST) has ensured through its semen bank that breeds such as the vulnerable feral Bagot goat, with a population of only 300 to 500 worldwide, and the minority breed, the Golden Guernsey, with a population of between 50 and 1,000, stay firmly established in the British Isles. The biggest problem with these low numbers is that the gene pool is small, so avoiding inbreeding and its associated problems of birth defects has been the main focus.

Sadly, in the UK the "old breeds"—the Old English, Old Welsh, Old Irish, and Old Scottish—have long gone, but periodically a hybrid goat will throw back the typical coloring and conformation of these goats whose value was not appreciated at the time and whose qualities were lost in the name of crossbreeding and improvement of the species.

Some of the older breeds, such as the Golden Guernsey, fell out of favor because other breeds such as the British Saanen were more prolific milk producers. The Golden Guernsey makes a perfect house goat, however, being compact and requiring less food, so its popularity is increasing.

Loss of natural habitat has been one of the greatest problems facing the feral goat. The Ibex, which forms the basis of most domestic goats today, still ranges free in many parts of the world including Asia and Africa and is the only true wild goat on the European mainland. The Alpine Ibex had become extremely rare and has been reintroduced in the Italian Alps in recent years.

In some parts of the world, goat populations have been threatened as they have been blamed for stripping forage, creating near-deserts, but in recent times it has been accepted that this is largely due to their management by human keepers. Ironically, man has rediscovered the importance of using goats to clear unmanageable scrubland in inaccessible places and improve upland grazing for future use by sheep.

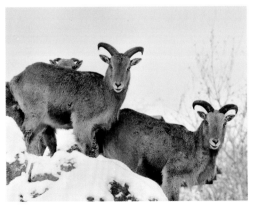

Left: The Alpine Ibex population was dangerously low in the mid-1800s but subsequent conservation measures have increased numbers.

SHOWING

SHOWS FOR ALL TYPES OF GOAT ARE AVAILABLE IN the US and beyond. State or national shows are the pinnacle, often running for several days with a range of categories.

Milk competitions are judged on the volume of milk produced by a dairy goat over a 24-hour period. Milk volume is weighed and cataloged by the judges and the most prolific milker and the one yielding the highest butterfat content are deemed the champions. At the other end of the scale are the classes for pet goats where any type or breed of goat can be shown.

All the breed types have their own classes and there are classes for AOV (Any Other Variety). Judges at these shows are looking for the prime example of the goat's breed standard.

Each breed has categories for all denominations, which may include kids, goatlings (yearlings), milkers, wethers (neutered males), and bucks (billy goats). Often there are classes for family groups as well, where a doe (female) may be shown with perhaps her kid from that year and a goatling born to her the previous year.

Preparation for showing begins as young as possible by teaching the goat to lead quietly in hand with either a lightweight halter or more frequently a lightweight collar and lead. It must be used to being bathed and groomed and having its hooves pared and trimmed, and also to traveling in a trailer. Often goats get quite shaky on their first trip in a vehicle, so plenty of practice is needed beforehand.

Female goats are trimmed of all excess head hair including beards, which all adult goats display. Some showmen will clip any excess hair off the udder region as well to show the udder shape. Hooves are carefully sanded to shape and then oiled to give them that show sheen. Coats are groomed to perfection and can be given a coating of silicone spray to really enhance their gleam.

The person showing the goat must, too, be neatly turned out and not detract in any way from the judge's eye falling on the goat. The handler must stand the goat up squarely for the judging and the goat should walk efficiently in hand to show its action and conformation.

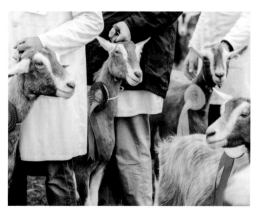

Left: The competition at shows is increasingly fierce; they are becoming popular events with large audiences of adults, kids (and kids).

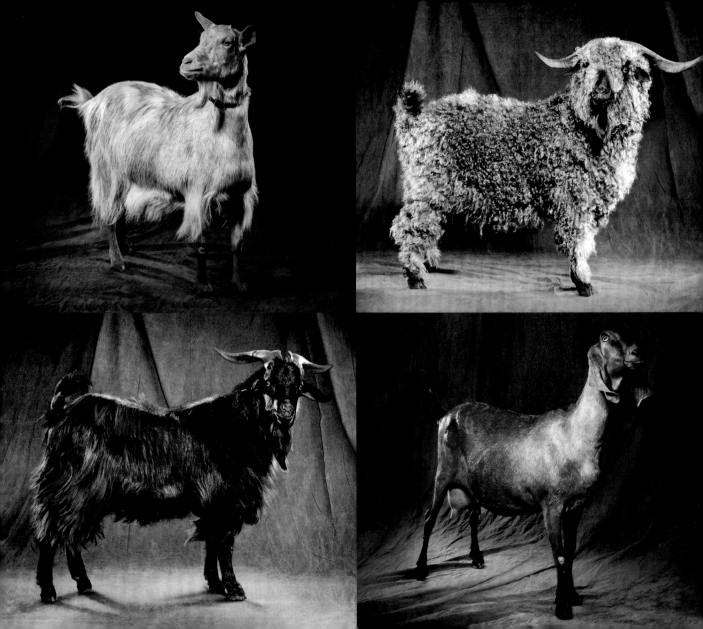

THE GOATS

Check out our gamut of gorgeous
goats in all their glory, photographed in
all their great variety for your gratification.
Goats are prized and loved on the farm,
in the show ring, in the yard, and in the
following pages. Enjoy our handsome,
happy, horned, (or hornless) herd.

BRITISH GUERNSEY

1-YEAR-OLD DOE GOATLING

The BRITISH GUERNSEY is a crossbred goat, derived from a Golden Guernsey male being bred to another dairy breed. As no Swiss markings are allowed for registration purposes, the preferred choice of female is likely to be a Saanen or British Saanen. This is a relatively "young" breed as the first Golden Guernseys were only imported to mainland Britain in 1965.

Features

Some British Guernseys are quite difficult to differentiate from their purebred cousins, the Golden Guernsey, as they inherit their strong chestnut coloring. The majority will be paler in color and although no Swiss markings are tolerated, patches of white are acceptable. The coat may be short or contain long hair, especially around the shoulder and thigh, and it may have tassels under the jaw. Horns, if present, are long and swept back.

Uses

This is a perfect homesteader's goat that will produce a good milk yield of perhaps 2,200 lb (1,000 kg) per lactation with a butterfat content of about 3.75%, making the milk suitable for both cheese and yogurt making.

Related Breeds

The Golden Guernsey will inevitably be the first cross sire and related females are likely to be both Saanen and British Saanen.

Size

Larger than the Golden Guernsey with variations due to crossbreeding but approximately:

Buck 154–198 lb (70–90 kg)
Doe 154–187 lb (70–85 kg)

Origin & Distribution

The true and only home of the British Guernsey is the British Isles!

British Isles

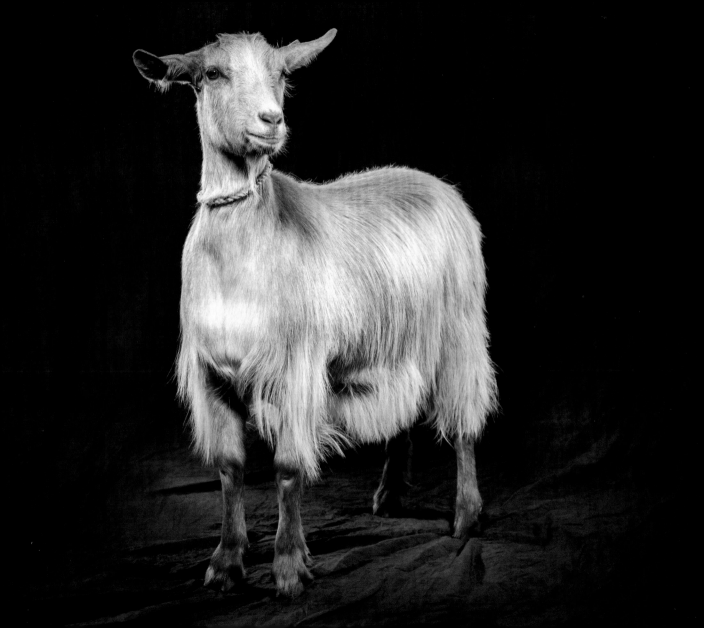

PYGMY

6-YEAR-OLD BUCK

Huge in personality but small in stature, the PYGMY goat is a prolific and popular breed. Used as meat goats in their indigenous countries, Pygmy goats are more usually seen as pets and show animals in the Western world, the combination of their bold and courageous nature and "take me seriously" stance being much loved inside and outside the show ring.

Features

A thick-set, short-statured goat of not over 22 in (56 cm) in height, the Pygmy has a substantial, muscular body and short legs and is alert and full of energy. Any color is acceptable except pure white or Swiss markings as are seen in the dairy breeds. The male should have an abundant coat with a mane and long beard. Both sexes are horned.

Uses

The milk supply of the Pygmy—a popular homesteader's goat—is not prolific; however, a Pygmy buck is quite capable of breeding with a larger dairy female in order to keep her milking and she will produce kids that are more likely to grow to her size than his. Pygmy goats are also used as pets and show animals.

Related Breeds

All miniature and dwarf goats have their origins in the Pygmy and Nigerian Dwarf breeds. Their size is attributed to the original West African Dwarf and Sudanese breeds.

Size

Buck44–55 lb (20–25 kg)

Doe24–44 lb (11–20 kg)

Origin & Distribution

Originating in Africa, particularly East Africa and the Sudan, the Pygmy goat now has a worldwide proliferation.

Sudan

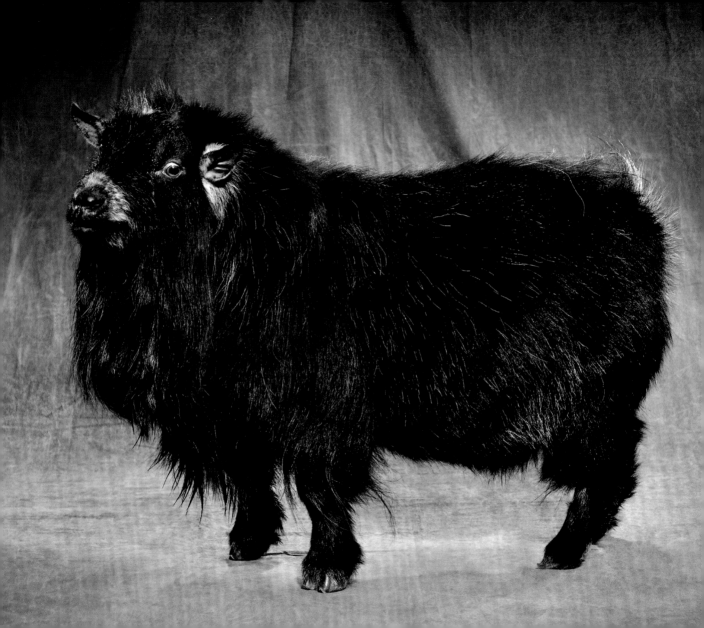

MINI LAMANCHA
4-YEAR-OLD BUCK

The Lamancha has its origins in Texas, where it was bred from imported short-eared Spanish goats brought from Mexico. One of these foundation goats was from La Mancha in Spain. During the 1920s and 1930s, the Lamancha was "bred up" by crossing with a variety of top-quality dairy stock males, producing a prolific dairy breed. The MINI LAMANCHA is a diminutive version of this breed.

Features

Both the standard and Mini Lamancha have short, stubby ears, which, if they are less than 1 in (2.5 cm) long, are known as "gopher ears." Some have longer ears of up to 2 in (5 cm) long, known as "elf ears." Only bucks with gopher ears are used for breeding, to maintain the acceptable breed characteristics. This goat has a fine, very shiny, short coat and can be any color.

Uses

Originally the Lamancha was a high-producing dairy breed—the milk has a very high butterfat yield making it good for cheese making—with miniature versions produced for the increasing desire in the American market for micro animals.

Related Breeds

The only goat with similar characteristics to the Lamancha is the rare Nambi goat (meaning "without ears") from Brazil, which has the same earless mutation.

Size

Mini up to 99 lb (45 kg)

Standard130–157 lb (59–70 kg)

Origin & Distribution

The Lamancha comes from the La Mancha region in Spain and nowadays is found in Mexico and Texas, with few goats of this breed found elsewhere. The Mini Lamancha was developed in the USA.

USA

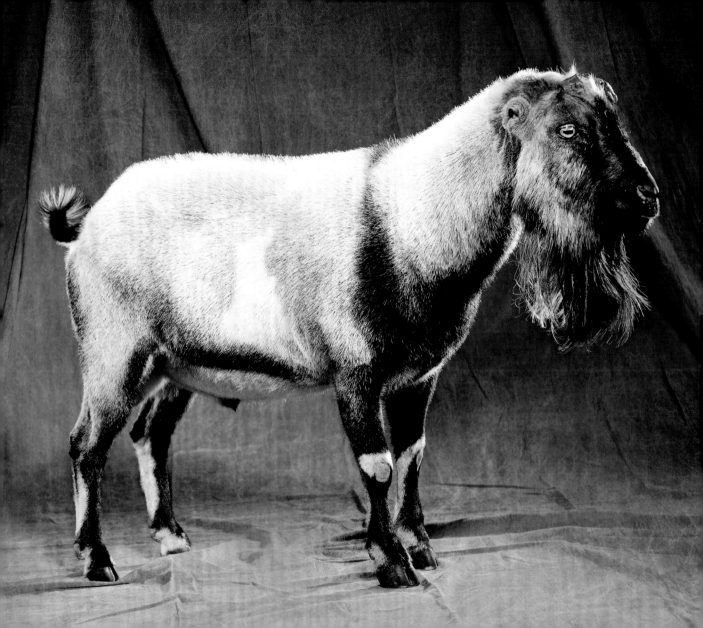

NUBIAN

1-YEAR-OLD DOE GOATLING

A lso known as Abyssinian and Indian goats, the exotic-looking NUBIAN first achieved acclaim in the Western world during the mid-19th century; the modern breed has been achieved by outcrossing. Often producing "litters," Nubian does can produce up to five kids in one birthing. Although small at birth, kids grow quickly to large, capacious goats with interesting and varied color combinations.

Features

The Nubian is a substantial goat. Lop-eared, with a gleaming coat, resonant head, and Roman nose, it is a true extrovert. Its long ears and an ability to close its nostrils have almost certainly evolved in its native regions to offer protection from desert sand-storms. It is usually hornless. Colors vary from same colored to patterning and marbling in a variety of mixes. "Snowstorm" ears, flecked with white, are a desirable trait to most breeders.

Uses

The Nubian is a high-yielding dairy goat with exceptionally high butterfat yields in its milk (average 5%). It is often used as a stock improver for size and dairy traits and is a very popular show goat.

Related Breeds

The Zairaibi goat of Egypt is the closest breed to the true and original Nubian. It has a distinctive arched head profile with protruding lower lips but is now very rare. Around the world there are country-specific variations.

Size

Buck176–265 lb (80–120 kg)

Doe141–165 lb (64–75 kg)

Origin & Distribution

Undoubtedly this breed originated in the Nubian desert region, but it is also widely found in India, Afghanistan, and Africa. Modern distribution is worldwide.

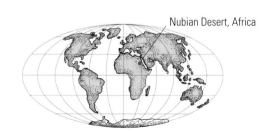

Nubian Desert, Africa

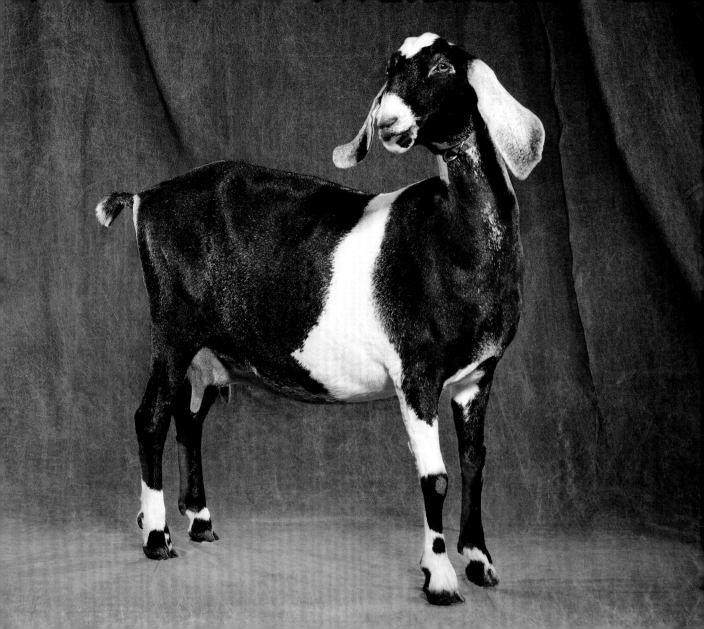

ANGORA

8-YEAR-OLD WETHERED BUCK

The Angora goat has found its place throughout the world as a prolific producer of the fiber known as mohair, which can be used for spinning, weaving, and for industrial purposes. Originating in Turkey, this breed was strongly protected until the middle of the 19th century and exportation was banned on penalty of death to the perpetrator!

Features

Throughout the world there are specific "types" of Angora goats and the portrait on the opposite page shows an Angora of the New Zealand type, characterized by its "handlebar" horns. There are variations of horn type within the breed and of fiber quality, which also reduces as the goat ages.

Uses

The Angora's hair is shorn twice yearly and is highly valued commercially and by home spinners. Each adult Angora goat will yield up to 13 lb (6 kg) of mohair a year. The fiber from kids and goatlings is considered the best quality. The Angora goat is never used as a dairy animal as its milk is needed for its offspring and much energy is also expended on the growth of coat fiber.

Related Breeds

The Angora is a true and original breed, although "grading up" of the breed has occurred by selective breeding. Outcrosses of the Angora include the Cashgora (Cashmere x Angora) and Pygora (Pygmy x Angora).

Size

Buck	176–220 lb (80–100 kg)
Doe	71–110 lb (32–50 kg)

Fleece weight 9–13 lb (4–6 kg) twice a year

Origin & Distribution

Originating in Ankara, Turkey, the Angora has now spread worldwide, with the greatest herd sizes being in Texas, South Africa, Australia, and New Zealand.

Turkey

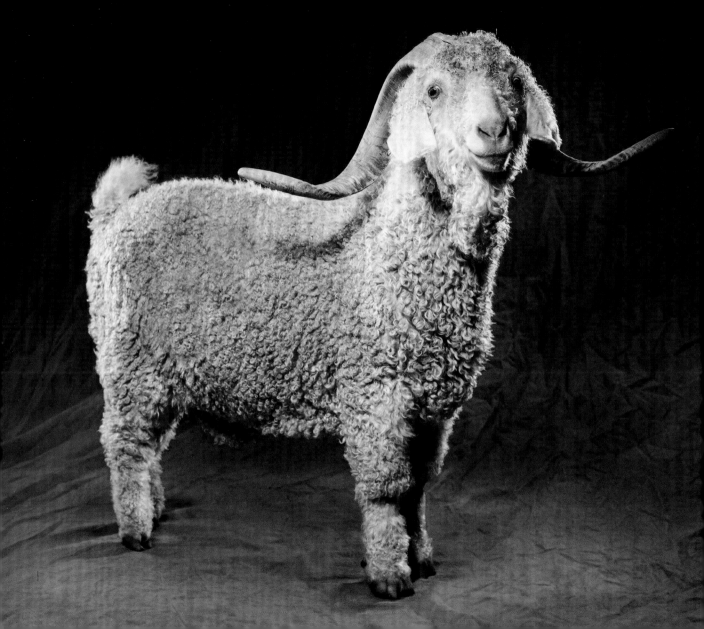

MINIATURE ALPINE
7-WEEK-OLD BUCK KID

The Miniature Alpine is derived from the Alpine Dairy Goat of America. It is a true miniaturized version of the standard breed. The origins of all Alpine goats lie in the European gene pool of the native goats of Switzerland, which are characterized more by color than by type.

Features

The Alpine is a hardy, graceful, light-boned, and adaptable goat in its standard form. It is smooth coated with typical Alpine markings on the face, under-body, legs, and rump. No white additional markings are tolerated although there are eight subdivided types dictated by coat coloring. This is a definite "two-tone" colored goat. It may be horned or polled (naturally hornless).

Uses

This mini version of the Alpine is aimed at the domestic market and those enthusiasts who show miniature breeds. In standard form the Alpine is a good general milking goat for the small farm or homestead, but the miniature version is also a viable small-scale milker.

Related Breeds

This goat was bred from Swiss and French Alpine types, then outcrossed to dwarf breeds to obtain small stature without loss of fine bone. A similar breed type is found in Brazil, known as the Repartida, which translated means "divided," referring to the color qualities of this goat.

Size

Buck	40–66 lb (18–30 kg)
Doe	26–55 lb (12–25 kg)

Origin & Distribution

Though the standard Alpine originated in Europe, the miniature version was developed in the USA. The Miniature Alpine is now also found in the Caribbean and Latin America.

USA

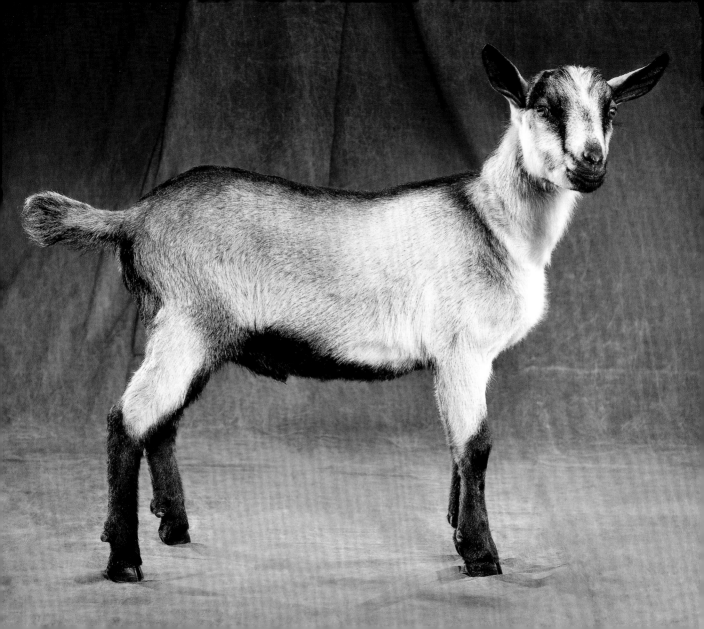

GOLDEN GUERNSEY
3-YEAR-OLD DOE

The GOLDEN GUERNSEY was decimated during the Second World War, when large numbers were killed for their meat. Miss Miriam Milbourne of L'Ancresse, Guernsey, hid a number of her goats in safety, and after the war she set about re-establishing the breed, making sure the distinctive golden coloring was maintained. By 1965 it was recognized officially that it was breeding true to type.

Features

This small, compact goat has a fine, auburn coat varying from honey-gold to deep russet. The skin is distinctive, varying from pink to golden and even orange or orange-red. The true "Island type" will not possess tassels but these are sometimes present as a result of "grading up" of individuals by using Golden Guernsey sires on Saanen x Golden Guernsey females.

Uses

Not considered a commercial milking goat in modern times, the Golden Guernsey is still a wonderful homesteader's goat, its milk containing a high butterfat content. It has a sensitive disposition and forms strong attachments to its handlers.

Related Breeds

The British Guernsey and the English Guernsey are both derived from the Golden Guernsey. There is some speculation that in previous centuries the Golden Guernsey was closely related to the Maltese goat.

Size

Buck	198–264 lb (90–120 kg)
Doe	132–176 lb (60–80 kg)

Origin & Distribution

Originating in the Channel Islands, essentially Guernsey, the Golden Guernsey is distributed throughout Britain.

Guernsey, British Isles

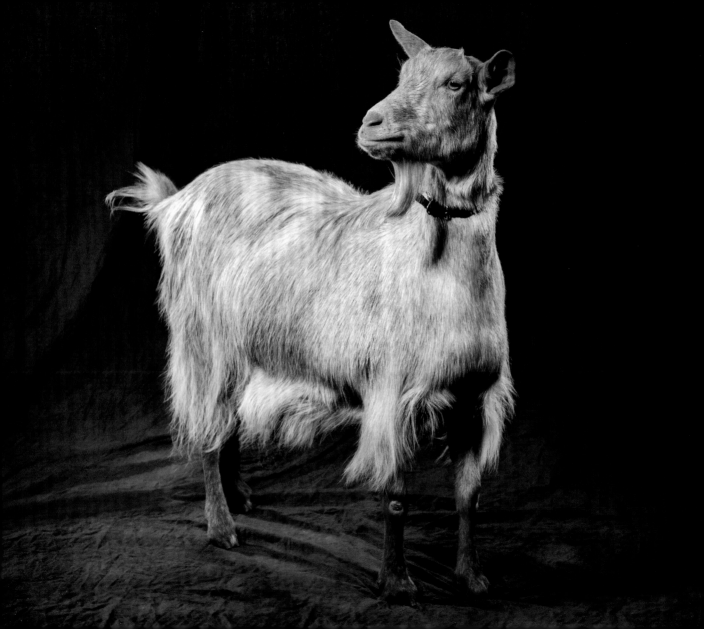

BRITISH TOGGENBURG

5-YEAR-OLD WETHERED BUCK

Developed from six Toggenburg goats imported from St. Gallen, Switzerland, in the 1880s, the BRITISH TOGGENBURG became a breed in its own right by the 1920s, developed from crossing these original goats with mixed Swiss breed types such as the Saanen and the British Alpine, the latter influencing coat color.

Features

A medium-size goat and larger than its Toggenburg cousin, the British Toggenburg has a light fawn to dark brown coat with various mousey shades in between. The coat is short with typical Swiss markings. This breed is usually born with horn buds, which will develop into large horns. Although some goats will have their horns removed at a young age, the buck pictured here displays a pair of horns to be proud of. Interestingly, these horns are identical to those of the Grisons Chamois (of Chamoisee breeding), an ancestor from 19th-century Switzerland.

Uses

Essentially a dairy goat, the British Toggenburg is a slightly more prolific milker than the Toggenburg, the annual average lactation being 2,645 lb (1,200 kg) with a butterfat content of 3.69%.

Related Breeds

Both the Saanen and British Saanen carry Toggenburg blood. The white Apenzell goat was originally 50% of the Swiss Toggenburg, along with the Chamoisee (a brown through to black color), which is responsible for the Toggenburg and British Toggenburg's color.

Size

Buck 132–176 lb (60–80 kg)

Doe 132–154 lb (60–70 kg)

Origin & Distribution

From Swiss origins, the British Toggenburg is now found throughout Europe and there have also been exports worldwide.

Switzerland

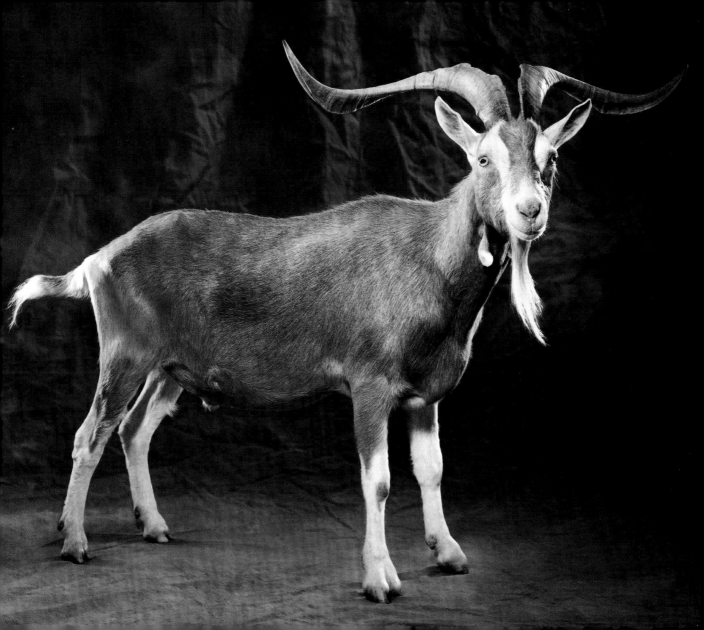

ANGORA

8-MONTH-OLD DOE KID

Although Turkey is their native home, ANGORA goats started to be bred in South Africa in the mid-19th century, and were subsequently crossed with the indigenous Cape goat. The Angora is possibly one of the oldest breeds known to man. It is highly prized for its luxuriant mohair fleece, known as the "diamond fiber" because of its shine and luster.

Features

The Angora is a small- to medium-size goat, with strong hindquarters and swept-back or twisted "handlebar" horns. It is often confused with a sheep on first encounter but, unlike a sheep, it has an absence of lanolin in its fleece to protect it from the cold and wet, so needs draft-free shelter.

Uses

The Angora is usually kept commercially as a fiber goat or by homesteaders for hand spinning where color is valued. The first and second shearings in young goats are the most valuable. Coarser fiber from older goats can be used in industry for a multitude of uses though—the most surprising of which is inclusion in the manufacture of conveyor belts to ensure they run smoothly.

Related Breeds

Influential in the early days of Boer goat production, the Angora continues to influence breed outcrossing such as the Pygora (Pygmy x) and the Cashgora (dairy goat of any breed cross).

Size

Buck 110–154 lb (50–70 kg)
Doe 88–132 lb (40–60 kg)
Varies in size according to global location. Fleece weight 4–22 lb (2–10 kg) twice a year.

Origin & Distribution

Originating in Turkey, the Angora is now widespread, especially in South Africa, New Zealand, Texas, Canada, and Europe.

Turkey

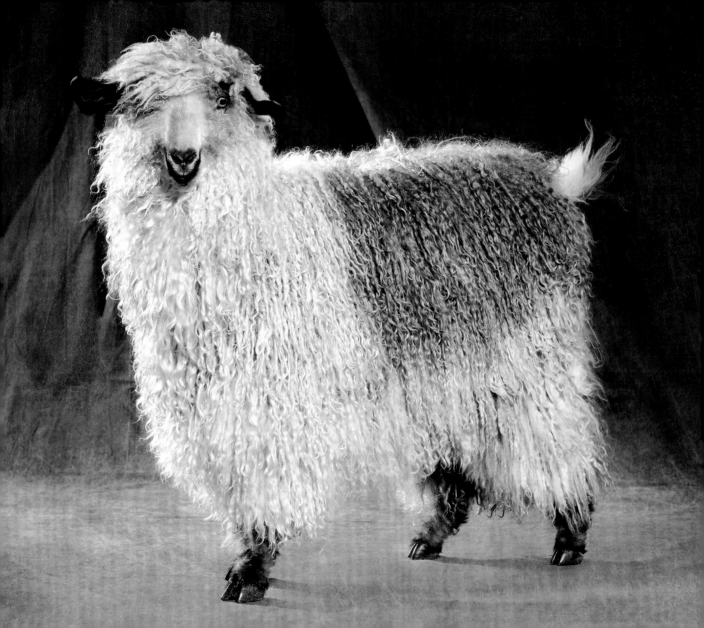

BRITISH SAANEN

2-YEAR-OLD DOE

The largest breed of the "white" goats and derived from the Saanen, the BRITISH SAANEN gained popularity in the UK in the early 1920s as a prolific milking goat. An earlier importation in the 1900s was less popular, though, when it failed to compete with the Toggenburg for milking prowess. Selective breeding improved this issue, however.

Features

The British Saanen is a strong, solid "leg at each corner" goat and has a white or cream coat, often flecked or patched with darker colors. The doe has short, fine hair but bucks often have a mane of longer hair. Generally polled, the breed produces animals with horns, which are swept backward.

Uses

The British Saanen is the first choice for most commercial milking concerns due to the high yields (averaging more than 2,645 lb (1,200 kg) with 3.68% butterfat content per annum). It is also an excellent homesteader's goat. Castrated males grow to a good size and are useful for meat production. This breed has also been used as a pack and driving goat.

Related Breeds

The British Saanen was bred using Dutch Saanen stock outcrossed to Toggenburgs. The British Guernsey is an outcross between a Golden Guernsey and a Saanen. There are national variations of the Saanen throughout the world.

Size

Buck	180–200 lb (80–90 kg)
Doe	140–180 lb (65–80 kg)

Origin & Distribution

Bred from imported Saanen stock from Switzerland, France, Belgium, and Holland, the British Saanen was given its own Herd Book in 1925. It is found mostly in the UK.

UK

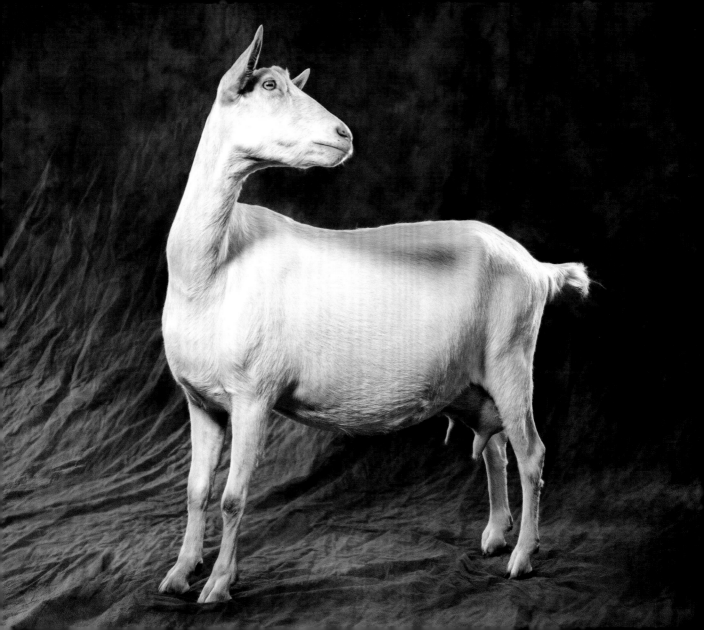

BOER

20-MONTH-OLD BUCKLING

The BOER (meaning "broad") was first recognized as a true breed in South Africa in the 19th century where its size and stature were improved through selective breeding. These were then further improved once it was exported to Germany and subsequently around the world. It is a meat-specific goat, bred to provide large, lean cuts in a reasonably short time.

Features

A large, heavily built goat, the Boer has a slightly Roman nose and drop ears. It has a short, close coat and is ideally white with a chestnut head and white blaze; although various color variations, such as the one pictured, are bred by enthusiasts, particularly in the USA. The South African Boer Goat Association has strict breed standards, which are mostly followed by other countries, though some variation does exist.

Uses

Most Boer keepers concentrate on producing quality carcasses but there is an increasing demand for Boer show goats. Boers are rarely kept as dairy animals as their milk is needed to rear their young for the more valuable task of providing meat.

Related Breeds

The Boer undoubtedly carries genetics from the Anglo-Nubian goat. It almost certainly originated from the feral "Hottentot" goat, indigenous to the Cape of South Africa, which was first found by European immigrants as early as the 17th century.

Size

Buck176–242 lb (80–110 kg)

Doe176–242 lb (80–110 kg)

Origin & Distribution

Originally found in South Africa, the Boer was subsequently exported and is now firmly established throughout the world.

South Africa

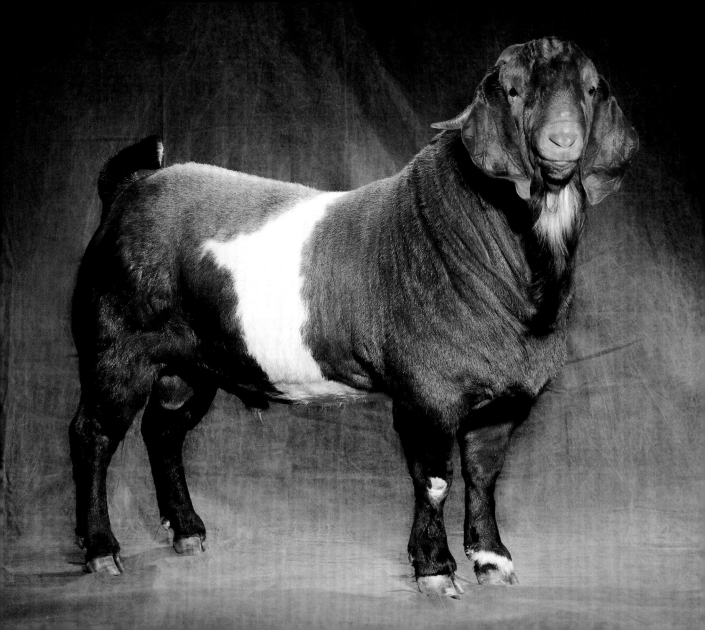

PYGMY

6-YEAR-OLD WETHERED BUCK

There are two types of Pygmy goat, both of which originated in Africa. One is an achondroplastic dwarf (short legs and a typical "pot" belly) while the other, originally from South Sudan, is a small, correctly proportioned animal. The West African type of this breed is the more frequently seen. In its native land, it was, and still is, a provider of milk and meat.

Features

The Pygmy goat has a huge personality and is easily kept on a small area of land due to its diminutive size. There are many color variations of the West African type and it is usually horned. The buck shown here is a West African type and has a particularly unusual horn formation that is more typically seen in the Central Asian Cashmere group of goats such as the Wuan.

Uses

The West African type is essentially a meat and skins goat in its native home and it can also be used for milk production. However, the Pygmy is more often kept as a pet and show animal in the Western world and has increasingly become an enthusiast's goat.

Related Breeds

Many deliberate outcrosses from the Pygmy goat are seen, including the Pygora (Angora x Pygmy). The Nigerian Dwarf, Nigerian goat, Benin, Zaire, and West African Dwarf are all similar related breeds from West and South Africa.

Size

Buck 44–55 lb (20–25 kg)
Doe 33–44 lb (15–20 kg)

Origin & Distribution

Originally this breed came from Africa, with particular types from West Africa, Cameroon, Nigeria, and Sudan, but it is now widely distributed throughout the world.

Africa

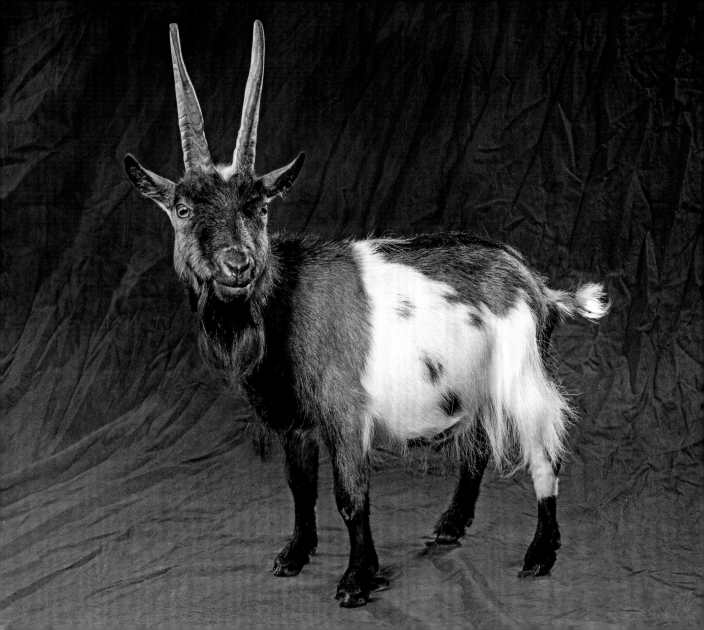

BOER CROSS
1-YEAR-OLD DOE GOATLING

The definitive meat goat, the Boer is used extensively to improve breeding stock to add "hybrid vigor," otherwise known as size and substance. The Boer is not generally regarded as a milking goat in the modern world, and a BOER CROSS will produce offspring that are far more viable meat producers due to their Boer genes. The Boer was developed and improved within South Africa and latterly in Germany.

Features

Displaying the typical added strength that crossbreeding of this type produces, this outcross shows the close glossy coat and conformation that typifies the Boer goat while displaying color not normally found in this breed in modern times. The lop ears and powerful body conformation tend to be dominant genetic features, as are the swept-back horns and Roman nose.

Uses

Although this example is a champion showing goat, she has the capability of producing kids that could "grade up" to the Boer breed eventually if she is bred again to a Boer buck or she could be bred back to a dairy breed.

Related Breeds

The purebred Boer goat would be the closest related breed to this crossbred goat. The Boer itself almost certainly descends from the Nubian goats that are thought to have accompanied African tribespeople in previous centuries.

Size

Buck176–220 lb (80–100 kg) approximately, depending on outcross

Doe110–165 lb (50–75 kg) approximately, depending on outcross

Origin & Distribution

Originating from indigenous South African tribal goats, this goat is widely distributed throughout the modern world with numerous crossbreeds.

South Africa

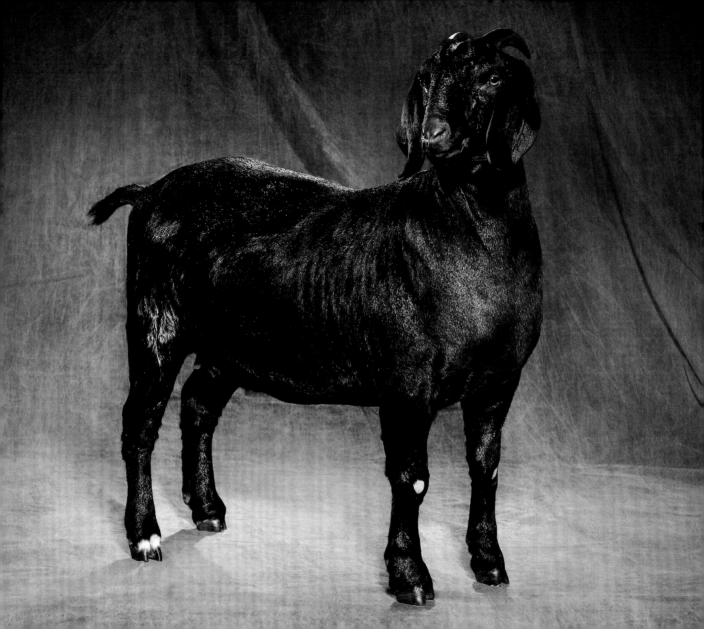

AOV

1-YEAR-OLD DOE GOATLING

The AOV is the abbreviation in the UK for "Any Other Variety." It describes a goat that is a crossbred and, although it may be registered in the Herd Book, it is not a breed in its own right. However, it can be used as part of the "grading up" process to develop a breed. Typically all crossbred goats, particularly on the first cross, will display "hybrid vigor."

Features

An AOV, as it appears in the show ring, should be a good example of a general-purpose goat for its type. In this case, the AOV is a dairy female. The goat pictured here has a strong Toggenburg influence and most of her offspring will perpetuate her Swiss markings.

Uses

The example shown is clearly destined for a dairy career but her castrated male offspring will also make useful meat animals. Her milk yield will largely depend upon her breed lines from both her sire and dam. She would undoubtedly make an excellent homesteader's goat, as well as a good pet and show animal.

Related Breeds

The breeds connected to an AOV will depend entirely on the crossbreeding used.

Size

AOVs on the first cross may grow to excellent weights. Care must be taken on the second outcrossing that the offspring do not revert to the smaller of the two breeds used.

Origin & Distribution

AOVs are seen throughout the world from either an accidental or deliberate breeding strategy. Often they are a result of a lack of local availability of the same breed of buck and doe. This AOV is from the UK.

UK

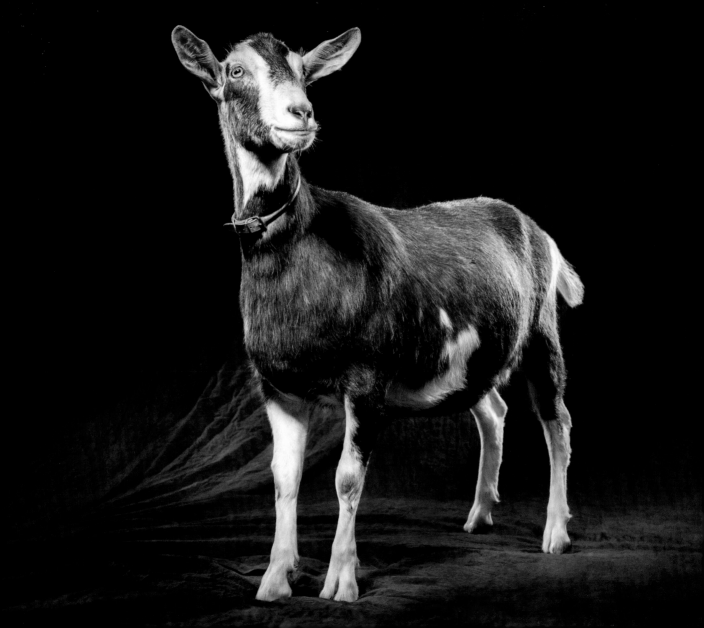

SAANEN

12-YEAR-OLD WETHERED BUCK

One of the most influential breeds in the development of British goats and indeed dairy goats worldwide, the SAANEN is usually the first choice of commercial dairy goat. It is descended almost entirely from Dutch stock imported in 1922 but an infusion of Swiss stock in 1965 helped to extend the gene pool. It is a docile goat as it was traditionally stall fed in its native Swiss valleys in winter.

Features

A white goat with no dark markings of any kind, the male Saanen has long hair on the head and along the dorsal line whereas his female counterpart will have a smooth coat with no fringing. This is a large and capacious goat with long legs and it is generally horned. Although most dairy animals will be disbudded as kids (horns removed), a few may be polled (naturally hornless).

Uses

This is an outstanding dairy goat producing on average 2,542 lb (1,153 kg) of milk per lactation year with a 3.8% butterfat content. The best males will be kept for breeding while others may be raised for meat production.

Related Breeds

The British Guernsey is produced from a crossbreeding of the Golden Guernsey and Saanen, and the British Saanen was originally produced by selective breeding with the Toggenburg. The Sable Saanen is an accepted breed in the USA.

Size

Buck 187–198 lb (85–90 kg)
Doe 132–154 lb (60–70 kg)

Origin & Distribution

Originating in the Saanen Valley of Switzerland and then progressively exported, the Saanen is found throughout Europe, America, Australia, and New Zealand.

Switzerland

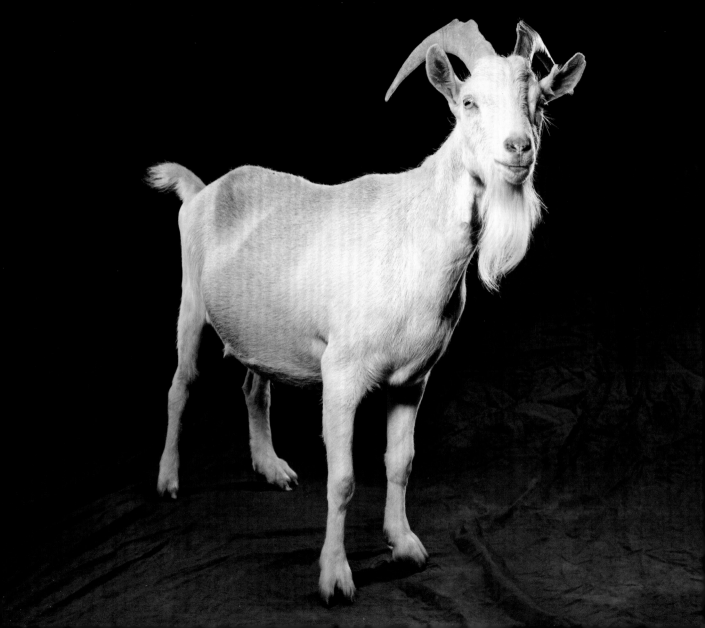

AFRICAN PYGMY

1-YEAR-OLD DOE GOATLING

The African Pygmy is considered by many to be the ultimate choice of pet goat. All of the Pygmy breeds, with their early origins in Africa, are delightful, energetic, and compact little goats with double the entertainment value of the larger breeds. Highly athletic, this breed can enrapture audiences and has become a firm favorite in petting zoos throughout the world.

Features

The African Pygmy is a stocky, easily kept goat that requires significantly less food than larger breeds, and enjoys being kept in large groups. Females can produce anything from one to four kids at a time, providing sufficient milk for them all. A huge variety of coat colors and lengths can be seen in this breed.

Uses

The African Pygmy's main worth nowadays is as a pet and show breed, with its cheeky character, good temperament, and cute stature winning it fans across the globe. Previously, however, this breed was a favored choice for meat on the African plains when food was short.

Related Breeds

The West African Dwarf, the Congo Dwarf, and the Marungu goat of Zaire are related, but although the variations on a theme from country to country are enormous, the personality stays the same!

Size

Buck33–55 lbs (15–25 kg)

Doe33–55 lbs (15–25 kg)

Origin & Distribution

The African Pygmy originated from Western and Central Africa but now has worldwide distribution.

Africa

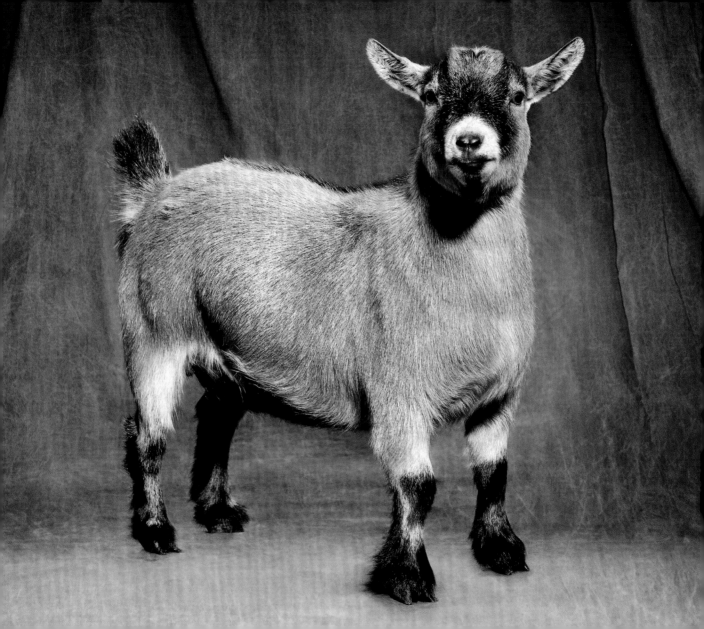

SABLE

1-YEAR-OLD DOE GOATLING

The SABLE is actually a Saanen goat but is not the usual white color. It was created by the pairing of two recessive genes found in Saanen dairy goats in the early 20th century that bore color and subsequently it has become a breed in its own right. It was only officially recognized by the American Dairy Goat Association in 2005.

Features

The Sable is a medium- to large-size, elegant dairy goat. It has refined features with typical Saanen conformation and a large, well-balanced udder in relation to the body conformation. White or cream goats are not tolerated in this breed but their coloring can be anything in the range of gray through brown and black. White markings are acceptable to the breed standard.

Uses

With 3.5% butterfat content in its milk, this is essentially a dairy goat that is suitable for both the homesteader and the commercial producer. Increasing in popularity in the last decade, it is being seen increasingly in the show ring in both the standard and miniature forms.

Related Breeds

The white Saanen is the foundation stock of this breed. There are also Mini Sables being bred both for the pet and showing market.

Size

Buck 132–176 lb (60–80 kg)

Doe 132–154 lb (60–70 kg)

Origin & Distribution

The Saanen originated in Switzerland but the resulting Sable originated in the USA. They are becoming increasingly popular in Australia and New Zealand where they are currently considered a rare breed.

USA

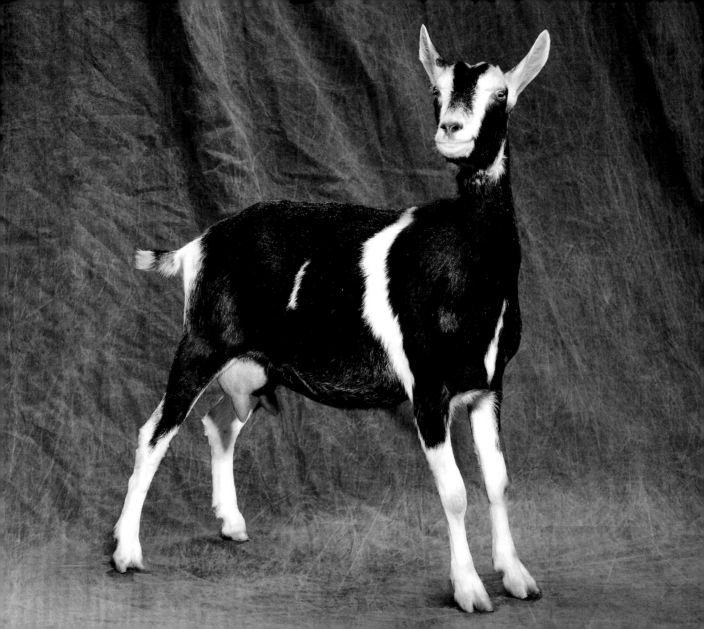

ANGLO-NUBIAN
4-YEAR-OLD DOE

This is a popular breed of British dairy goat derived from over a century of selective breeding from goats imported from Africa, India, and the Nile region. Recognized by the British Goat Society at the turn of the 20th century as a breed in its own right, the ANGLO-NUBIAN went from strength to strength and its own breed society was formed in the UK in the mid-1960s.

Features

Aloof and elegant with a docile and adaptable disposition, the Anglo-Nubian is the tallest breed of British goat. It has a shiny, short coat with no long hair or tassels beneath the head, and a well-set udder on a strong, long body. Horns, if they are present, should be smooth and backward sweeping. This goat produces large numbers of small but fast-growing kids in a variety of colors.

Uses

The Anglo-Nubian is essentially a prolific dairy goat with high milk and butterfat yields of 2,200 lb (1,000 kg) per annum and 5% butterfat content. Castrated males can be used for meat production from an early age.

Related Breeds

The rare Zairaibi goat from Egypt and the Bricket Cross from Chitral, which is on the borders of Afghanistan, Kashmir, India, and Pakistan, are the closest relatives to this goat.

Size

Buck 308–441 lb (140–200 kg)
Doe 308–419 lb (140–190 kg)

Origin & Distribution

While its origins lie in India, Africa, Afghanistan, Kashmir, and Egypt, the Anglo-Nubian was bred specifically in the UK. Its popularity in Europe and beyond has spread and its influence can also be seen in some of the miniature American breeds.

UK

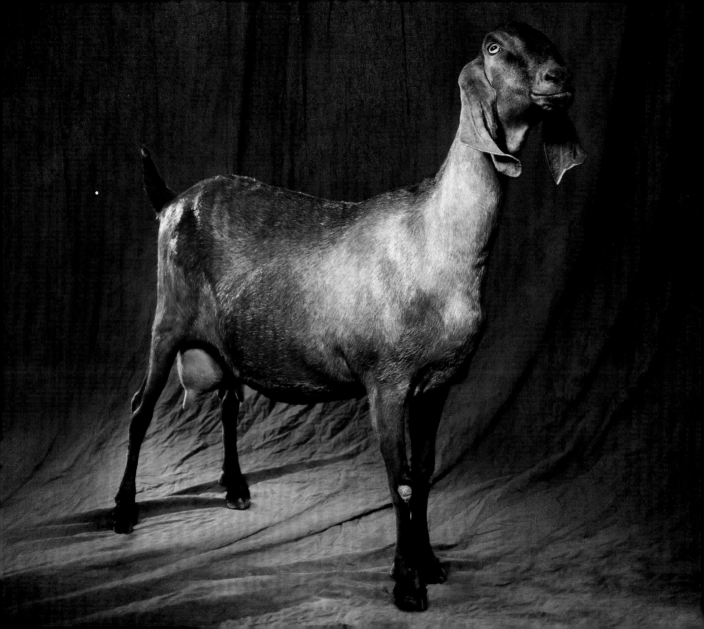

MYOTONIC MINI SILKY

11-MONTH-OLD DOE KID

A miniature utility goat, the MYOTONIC MINI SILKY was very much bred for the pet and US showing fraternity. The original standard-size myotonic or "fainting" goat was produced as a meat goat in Tennessee. Four were reportedly introduced by John Tinsley, who settled there from Nova Scotia but then left them behind when he moved on. All myotonic goats originate from these four animals.

Features

This extraordinary goat has a hereditary muscular defect that causes it, when startled, to become rigid and topple over. It is not a true faint as the goat does not lose consciousness, but this malady makes it very vulnerable to predation. The coat is long by definition and although its coloring is generally white with black or dark markings, other color combinations are now seen.

Uses

The standard-size goat is still used extensively for meat while the miniature variations are aimed solely at the enthusiasts' market as demand for small-stature animals increases.

Related Breeds

The Myotonic Mini Silky is related to the original standard-size myotonic meat breed and there are numerous variations on coat and color type.

Size

Buck 27–55 lb (12–25 kg)

Doe 27–55 lb (12–25 kg)

Origin & Distribution

The Myotonic was first introduced to Marshall County, Tennessee, in 1880 although it may have been imported from India at a similar time. This miniature version was developed by enthusiasts in the USA and has not been distributed elsewhere.

USA

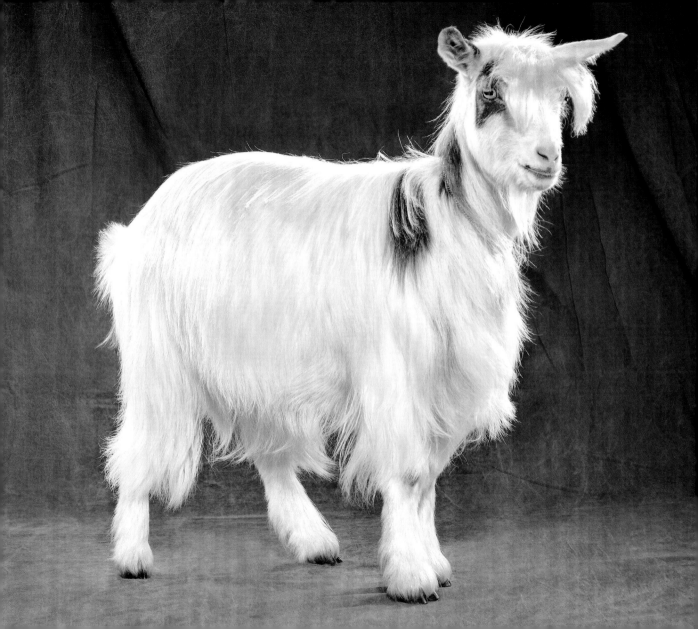

BRITISH FERAL

6-YEAR-OLD WETHERED BUCK

Feral goats have wandered the landscape since the very beginning of man's domestication of animals and this BRITISH FERAL can still be seen in various locations in the British Isles today. Through random natural breeding, this goat has reverted back to a type seen and documented in the UK in the early 18th century; a type is often seen in paintings of the time.

Features

Small, svelte, and of athletic build with almost any coloring and horns, the British Feral must be fleet footed, hardy, and capable of foraging wild herbage. It must have the ability to find natural shelter in caves and overhangs and be able to raise strong kids that can be up and mobile within days of birth to ensure their survival.

Uses

The British Feral is a conservation grazer, capable of climbing and foraging where heavier breeds of goat would not be able to go. Numbers have to be controlled in order to avoid overbreeding and the potential of starvation through the winter.

Related Breeds

Without a doubt, feral goats worldwide, having been captured and domesticated, have become the foundation for all goat breeds today.

Size

Buck	44–55 lb (20–25 kg)
Doe	40–44 lb (18–20 kg)

Origin & Distribution

British Feral goats came about through trading and slave ships bringing animals from different countries to the UK in the 17th and 18th centuries. They were kept on board for milk and meat and then released once the ships docked.

UK

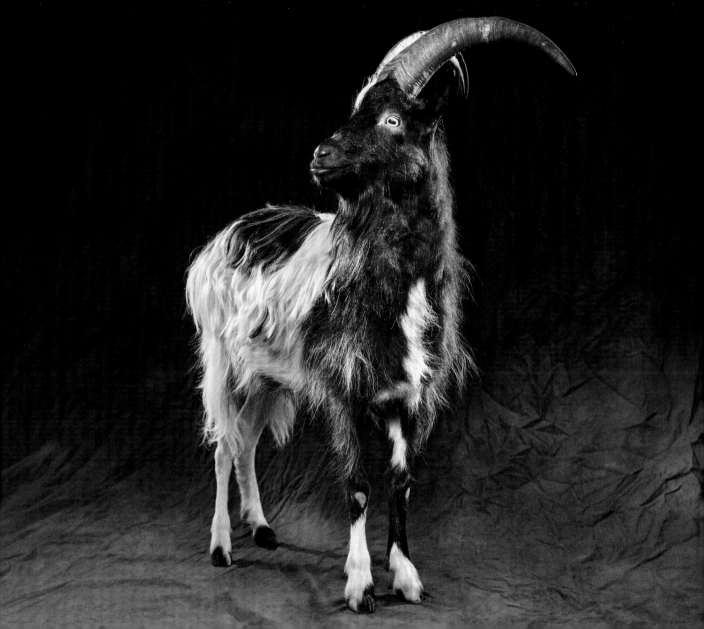

NYGORA

1-YEAR-OLD DOE GOATLING

An interesting, essentially American, crossbred goat, the NYGORA was produced from crossing a Nigerian Dwarf goat, which originated in Southern Sudan, with an Angora, which originated from Turkey. The Angora breed was imported into the USA in the 1840s and being the larger of the two breeds is more likely to be the sire of this outcross.

Features

The Nygora is soft coated and comes in a multitude of colors, and with varied horn shapes. This small goat displays hybrid vigor and is a miniature rather than a dwarf breed. This means it has all the normal proportions of its parents but these have been miniaturized while maintaining conformational substance.

Uses

This goat has a sheep-like fleece, the length and type of which depend on the genetic code of the goat at its conception. A good fleece is attractive to small-scale spinners and the pelts are also good for rugs. The Nygora is becoming popular with enthusiasts, homesteaders, and show people in the USA, where crossbreeding for color and type is acknowledged.

Related Breeds

The Angora goat and the Nigerian Dwarf are obviously the closest related to this type. The Angora is frequently used for outcrossing, particularly in the miniature and pygmy breeds. The Pygora (Pygmy x Angora) is also a cousin of the Nygora.

Size

Buck	33–155 lb (15–25 kg)
Doe	33–155 lb (15–25 kg)

Origin & Distribution

The Nygora originated in the USA and North America but it's likely to have been distributed to the UK and Europe, also.

USA

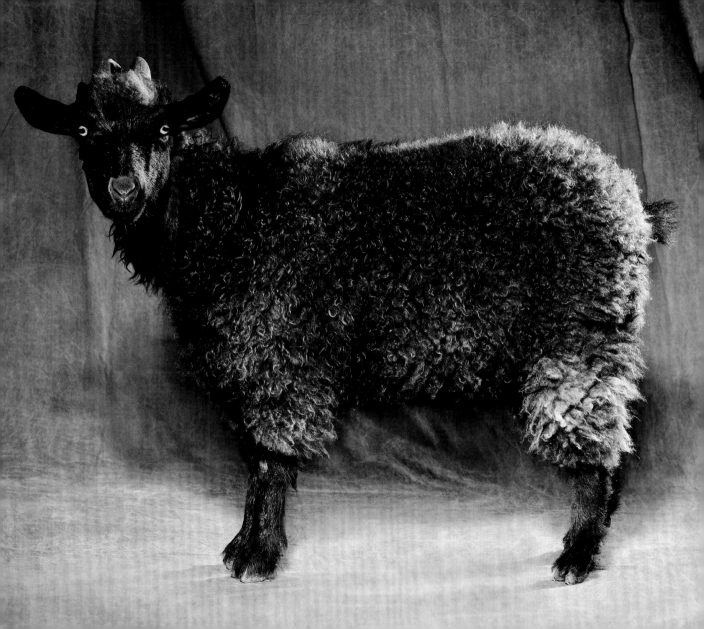

BOER
4-MONTH-OLD BUCK KID

Classified as a meat breed, the BOER goat, with its origins in the wild country of the Cape of South Africa in the 17th century, has developed into the large, vigorous modern goat we know today. Selective breeding for bulk and weight has ensured that this breed remains the number one choice for commercial goat meat producers worldwide.

Features

The Boer is a large animal with a heavily built conformation. It has a close, shiny coat that was originally chestnut and white, which is still the breed standard in South Africa. The spotted example, pictured, was bred in the USA—this color variation is increasingly in demand.

Uses

Rapid growth in young animals on good grazing, and without the need for concentrate feeding in most cases, has established the Boer as an economic commercial option. Essentially a meat breed, it is also kept by showing enthusiasts and for crossbreeding with dairy females. Genetic faults can occur with these outcrosses, so they are not normally kept for dairy use.

Related Breeds

Early Anglo-Nubian roots have influenced the breeding of this goat in modern times with regard to color variations but it can be traced back to the indigenous "Hottentot" goat and possibly the Angora over the last four centuries.

Size

Buck176–242 lb (80–110 kg)
Doe176–242 lb (80–110 kg)

Origin & Distribution

The Boer, originally developed as a breed in its own right in South Africa over a hundred years ago, is now widely distributed throughout the world.

South Africa

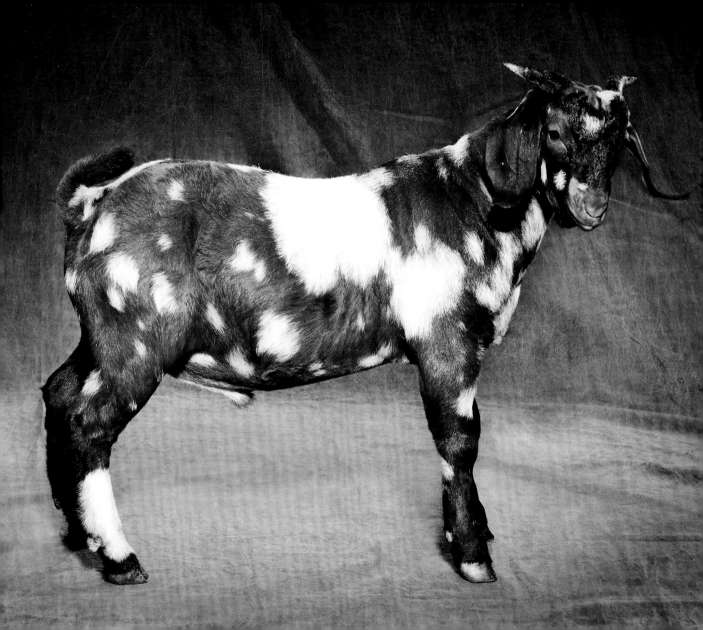

MINI SILKY

2-YEAR-OLD BUCK

The MINI SILKY Fainting Goat is a new breed that was uniquely developed in the USA by breeders Renee Orr and Frank Bayliss in the 1990s. It was created by breeding the Myotonic (fainting) goat with a Nigerian Dwarf goat, resulting in this attractive, small, long-coated breed with characteristics that are appreciated both by pet keepers and for showing.

Features

According to Association guidelines, the Mini Silky should have a full, long skirt of hair, long chest and neck hair, with a hairy face and beard. The "terrier" look is considered a desirable trait. The colors of its coat are varied. The "fainting" ability in myotonic goats is a genetic mutation, which is not always present in the Silky. It has its own Breed Association formed in 2005, which claims that these goats have a life expectancy of 20–25 years.

Uses

Entirely aimed at the pet and showing market, the Mini Silky is increasing in popularity among the micro livestock fraternity in the USA.

Related Breeds

The Mini Silky is derived from two breeds, the Myotonic, or Fainting Goat, and the Nigerian Dwarf goat, which is a Pygmy breed.

Size

Buck 25 in (63.5 cm) max. height
Doe 23½ in (60 cm) max. height
Accurate weights are currently unknown.

Origin & Distribution

Though this breed's antecedents came from Africa, in the case of the Nigerian Dwarf, and Tennessee, in the case of the Myotonic goat, the Mini Silky itself was developed solely in the USA. There is no distribution at present outside the USA.

USA

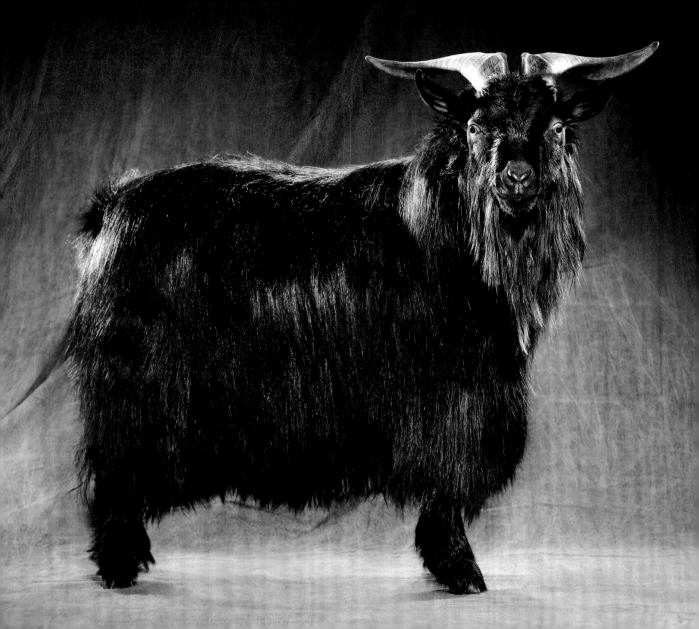

MYOTONIC

6-YEAR-OLD BUCK

Commonly known as the Fainting Goat, the MYOTONIC goat is so called for its tendency to become rigid and to fall to the ground motionless if it is startled or hears a loud noise. It does not lose consciousness and rises again within seconds or minutes. This is caused by a hereditary muscle defect known as myotonia. A breed society was established for the Myotonic in 1988.

Features

Other than the already described preponderance to fall over, this goat is easy to control as it is unable to jump over fences due to this condition. An obvious disadvantage, however, is that the condition makes it very vulnerable to predation. The Myotonic goat is medium size with a typically black and white (piebald) coloring, although other colors are now being produced.

Uses

Essentially, this goat is a meat breed although it is also kept for its curiosity value and has many breeders in the USA. Miniature versions are also kept as pets and for the showing world.

Related Breeds

The Myotonic goat is a unique breed. It is also known by several other names, including Texas Wooden Leg goat, Epileptic goat, and Tennessee Fainting goat.

Size

Buck 88–143 lb (40–65 kg)
Doe 88–110 lb (40–50 kg)

Origin & Distribution

This goat is thought to originate from four goats that were brought to Tennessee in 1880, which all suffered with this condition, though India has also been suggested as a place of origin. The home of the modern Myotonic is the USA.

USA

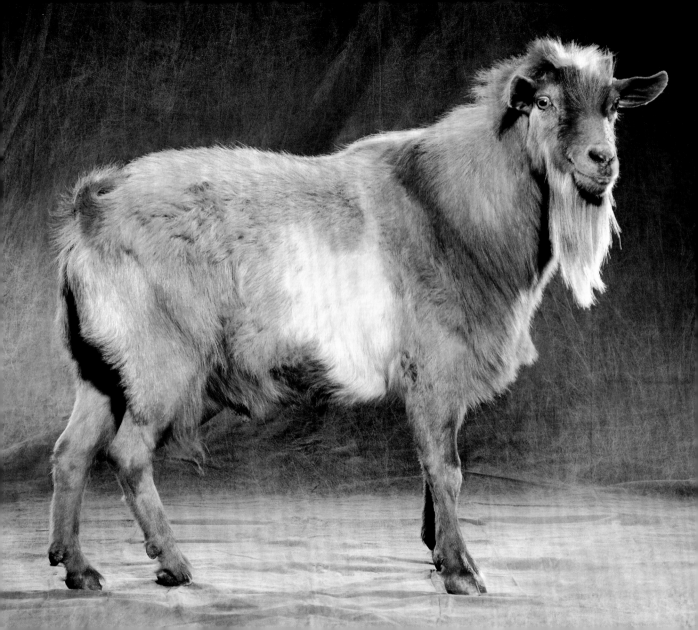

MINI OBERHASLI

8-MONTH-OLD DOE KID

An American breed of Alpine origin and once known as the Swiss Alpine, the MINI OBERHASLI is considered to be a rare breed. Its breed society was formed in 1977 after interest in the breed and numbers of stock grew following its introduction to the USA in the 1930s. Its name is derived from the Oberhasli-Brienz region in Switzerland, from which this breed originates.

Features

The Mini Oberhasli ranges in color from bay to black with typical Alpine markings running as stripes from above the eye to the muzzle. It has a black forehead and inner ears, and a dark dorsal stripe may run from the poll to the tail. The belly, udder, and lower legs are black and males can often have a blanket of black on the back. These are the color characteristics of the wild Chamois.

Uses

This is a useful dairy goat but because of its rarity it is mostly used for breeding further stock for enthusiasts. The Mini Oberhasli has been generally bred for the micro animal market in the USA. It is not considered a hardy goat and so needs specialized care.

Related Breeds

The Rock Alpine, bred by Mary Rock in California in the 1930s, was produced by crossing the Oberhasli with the Toggenburg to create a useful dairy breed. This variation became extinct in 1978.

Size

Buck33–55 lb (15–25 kg)
Doe33–55 lb (15–25 kg)

Origin & Distribution

The original breeding stock was from Switzerland and it is now found in the USA with minimal distribution worldwide.

USA

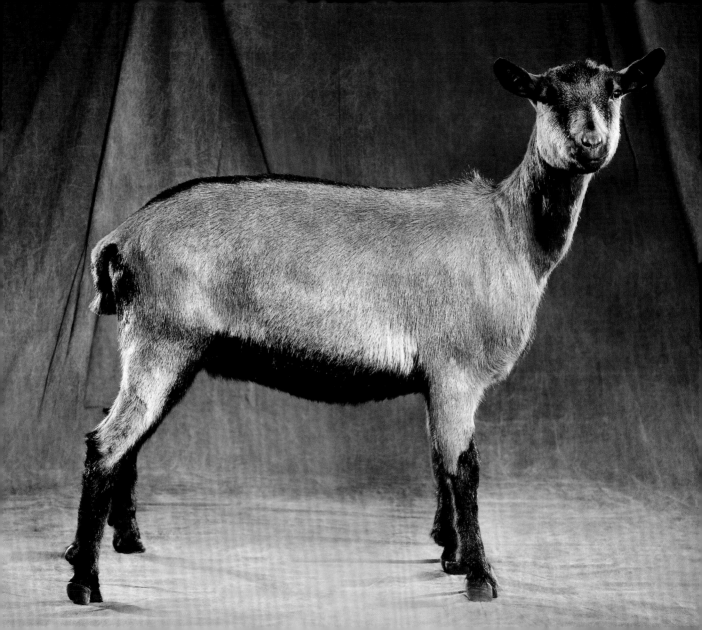

CASHMERE
10-YEAR-OLD WETHERED BUCK

The CASHMERE is known for its outstanding fiber, which is also known as pashmina, from where the garment name is derived. The true and original Cashmere goat undoubtedly came from high in the Himalayas in Tibet. From 1823 to 1936 there was a wonderful herd of Cashmere goats kept in Windsor Great Park, UK, which proliferated from a pair presented to King George IV.

Features

This goat has a diaphanous white or cream coat with soft wool under-fiber that can be 4–6 in (10–15 cm) long. The Cashmere has long "handlebar" horns, which are most distinctive in the Mongolian type. It is a fairly large goat with good maternal instincts.

Uses

Fiber production is the sole use of this goat although a distinct male line of "Windsor Whites" taken from the original Windsor Great Park herd is still used as ceremonial goats today. In their natural habitat of Kashmir, Tibet, Mongolia, and China, their fiber is an important source of income to their herders. Elsewhere in the world they are farmed commercially for their fiber.

Related Breeds

The Zhongwei, Mongolian, and Liaoning Cashmere goat breeds are all of a similar type and the New Zealand and British Cashmere type bear a strong resemblance to these. The Australian Feral goat is very similar to the Asian breeds.

Size

Buck88–121 lb (40–55 kg)
Doe77–110 lb (35–50 kg)

Origin & Distribution

Originating in Kashmir, Tibet, and Asia the breed is found extensively throughout the world including island communities such as the Falkland Islands and Tasmania.

Himalayas

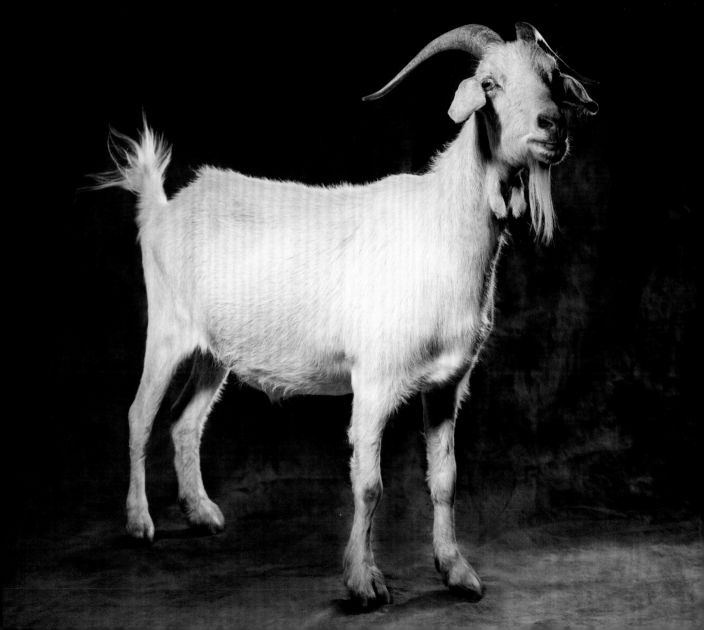

CASHMERE

1-YEAR-OLD BUCKLING

Correctly termed Kashmir as a breed, CASHMERE is the more commonly used spelling and refers to the combed under-wool from its coat. The original goats were white and most today still remain so, although a few may be found with gray, black, or even pied coats. The Western trend for home spinning has demanded more color in the coat, which has been achieved by selective breeding.

Features

A small, agile goat in its natural habitat, the Cashmere has a medium to long diaphanous coat that yields two combings each year of wool of approximately 6 in (15 cm) in length. This multipurpose goat is horned, hardy, and totally adapted to mountainous dwelling, being capable of dealing with temperatures ranging from -27°F up to 98°F (-33°–37°C).

Uses

Although prized in the Western world for its wondrously soft wool—which commands high prices—the Cashmere is used extensively for meat in its indigenous homelands, where it has served its often nomadic keepers for centuries.

Related Breeds

There are many cashmere-type breeds, including the white-coated Albas and Alashan Down, and the colored Gobi, Unjuul, and Uulin Bor. The Jining Gray and Zhongwei are kept for fur and pelt while the Chengde Polled and Wuan are meat producers.

Size

Buck 119–154 lb (54–70 kg)

Doe 119–154 lb (54–70 kg)
(Varies in size according to global location.)

Fleece weight 1 lb (500 g) per combing
(usually taken twice a year)

Origin & Distribution

The Cashmere originated from the Himalayas, Mongolia, Tibet, India, and Pakistan with derivatives worldwide.

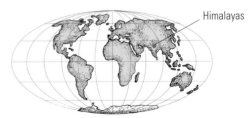

Himalayas

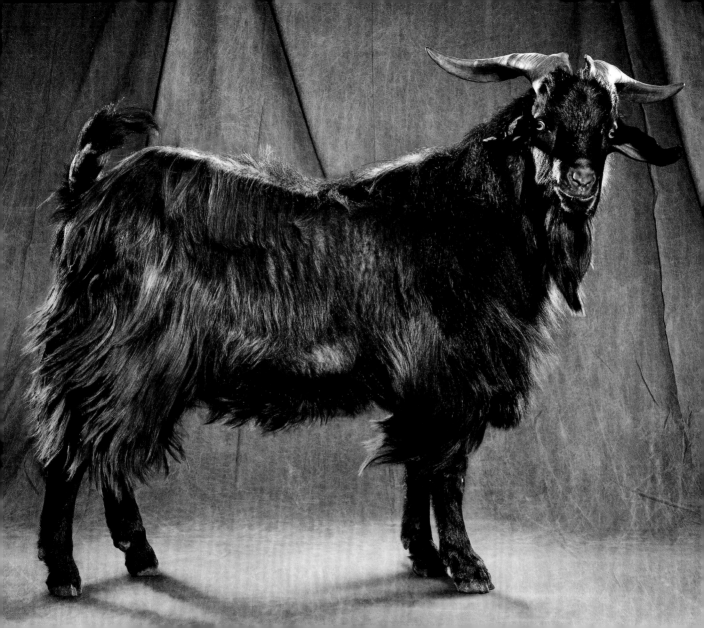

BRITISH ALPINE
8-YEAR-OLD DOE

The BRITISH ALPINE is a very attractive and robust British breed of goat derived from the Alpine types of Swiss goats. The word "Alpine" refers to the origins of these goats, which are from the Alpine mountain ranges, rather than the breed itself. After generations of crossbreeding for type and color, it achieved actual breed status in 1919 and its own Herd Book in 1926.

Features

The British Alpine has a pleasing, well-balanced conformation with a large body and a straight or concave facial profile with or without tassels at the angle of the jaw. The coat is short and fine and has no fringing. Its color should be jet black with white Swiss markings.

Uses

Essentially this is a specialist dairy goat with good milk yields. The average annual lactation is 1,763–2,204 lb (800–1,000 kg) with a 4.2% butterfat content, which makes the milk suitable for all dairy uses including cheese.

Related Breeds

All the Alpine goats will have similar breeding but, in particular the Sundgau goat of Alsace is likely to be an ancestor. The Grisons Striped was another goat instrumental in deriving this breed's distinctive, shiny black coat. Also influential were the Chamoisee and Tarentaise.

Size

Buck 132–176 lb (60–80 kg)

Doe 121–154 lb (55–70 kg)

Origin & Distribution

Originating from the Alpine (mountain) regions of Europe, this goat is now the specialist dairy goat in the UK.

UK

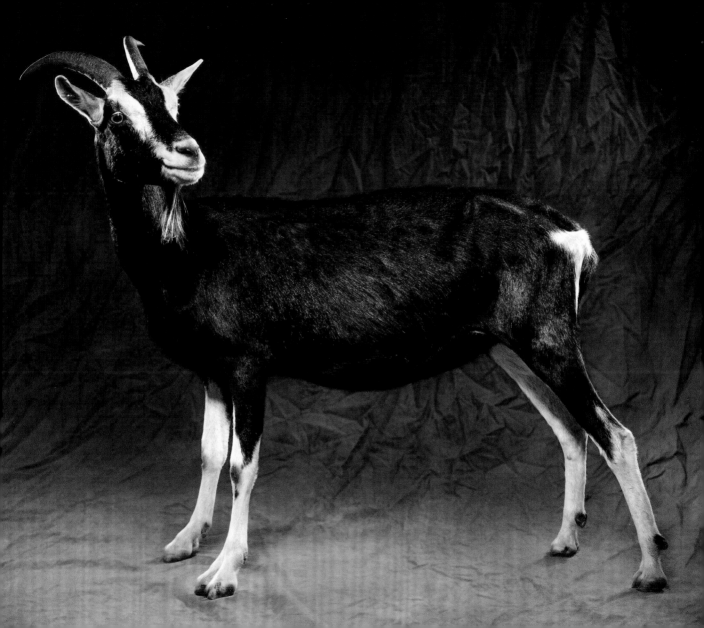

NIGERIAN DWARF
1-YEAR-OLD DOE GOATLING

A very similar goat to the Pygmy goat of Great Britain, the NIGERIAN DWARF is a surprising little goat in that it has retained its practical usefulness as a milking goat. This makes it ideal for a homestead or small farm where space is at a premium. It was first imported into the USA in the late 1950s.

Features

This tiny goat stands at approximately 18–20 in (45–50 cm) at maturity. It is fine boned and concave faced with a short, fine coat, and both males and females are horned. Unlike the majority of pygmy and dwarf goats, the Nigerian Dwarf is a perfect miniature of its larger cousins in the dairy world.

Uses

The Nigerian Dwarf is an excellent choice of goat for small-scale farmers. It requires low volumes of food compared to standard-size dairy goats but is capable of producing good volumes of milk with high butterfat, which is ideal for cheese making. Considerable interest in the showing world ensures that this important breed retains its original characteristics so valued by the herders of its native cousins.

Related Breeds

The Nigerian Dwarf is a close relative of the finer-type of British Pygmy goat. It is also related to the Small East African type of dwarf goat.

Size

Buck 44–55 lb (20–25 kg)

Doe 44–55 lb (20–25 kg)

Origin & Distribution

The origins of the Nigerian Dwarf are almost certainly in West and Central Africa. Nowadays it is found in North America, Europe, and the Mediterranean, with variants in the Middle East.

Africa

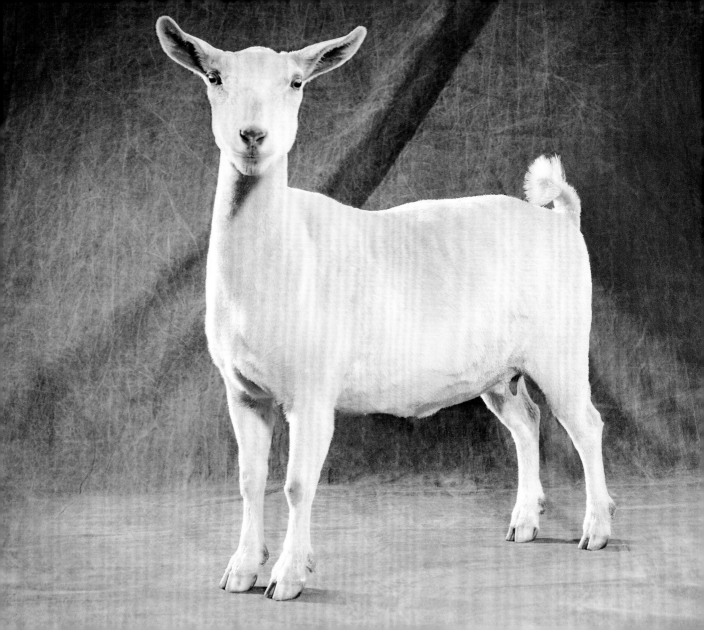

ANGLO-NUBIAN

6-YEAR-OLD WETHERED BUCK

This ANGLO-NUBIAN is the largest of all dairy breeds. Although Nubian goats can be found worldwide, this specific "Anglo" breed is British and became established in the UK in the 1960s. Despite its climatic origins (the Nubian originated from Africa), the Anglo-Nubian has adapted to the UK climate, although milk yields tend to drop in cold weather.

Features

This is a very stately goat, being tall, upright, and with a very loud voice. The large Roman nose of this breed makes it the Dame Nelly Melba of goat voices! The Anglo-Nubian has a hard, short, and shiny coat and has enormous color variation with patterning and spotting. The lop ears are a protection from sandstorms in its original native habitat of Africa. This goat can be horned or polled (naturally hornless).

Uses

This breed is an excellent dairy goat with high butterfat yields making the milk suitable for cheese making. The average annual lactation is 2,205 lb (1,000 kg) with a butterfat content of 5%.

Related Breeds

The closest related breed is the Zairaibi goat from Egypt. Although many lop-eared goats will carry the genetics of the Nubian, there are no other breeds directly related to the Anglo-Nubian.

Size

Buck 176–264 lb (80–120 kg)

Doe 140–165 lb (64–75 kg)

Origin & Distribution

This is a British breed, although the genetic origins of the Anglo-Nubian are in the Eastern Mediterranean, North and East Africa, and India. Ironically, it has returned to its roots in recent years by being exported back to these countries as a dairy goat.

UK

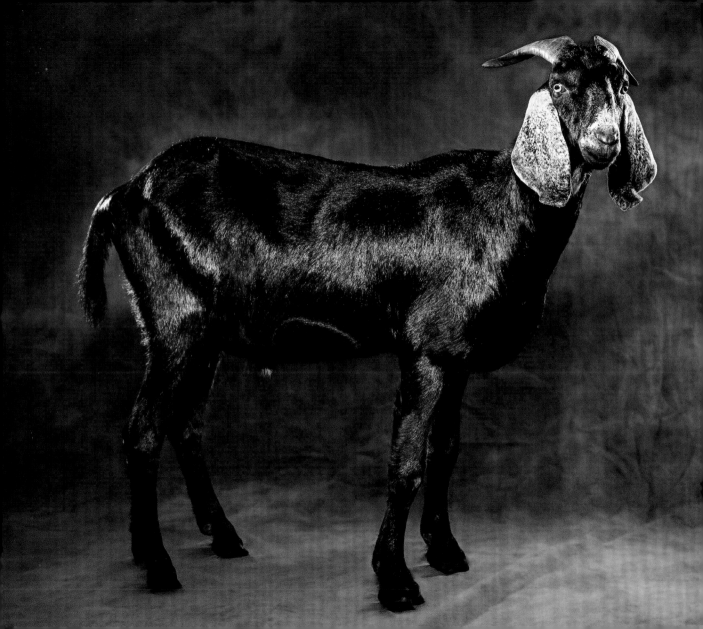

BRITISH TOGGENBURG

2-YEAR-OLD DOE

The Toggenburg was the first of the Swiss dairy breeds to be imported into the UK in the late 19th century. It was bred for increased size and within 20 years became a much larger individual than its Swiss counterparts. In early breed lines, the butterfat content of its milk was low. Through careful selective breeding, however, the modern BRITISH TOGGENBURG is now a firm favorite as a dairy goat.

Features

This is a medium-size dairy goat with lean conformation and a coat of short, fine hair which sometimes has longer fringing along the mid-line, thighs, and shoulders, particularly in bucks. The British Toggenburg has a slightly concave face and presents with or without tassels to the upper neck. It can be both horned and naturally polled. Generally it is a medium-brown in color although gray through to chocolate are found with typical Swiss markings to the face, belly, legs, and rump.

Uses

The British Toggenburg is a dairy goat with average milk yields around 2,645 lb (1,200 kg) per annum with 3.68% butterfat.

Related Breeds

Bred initially from the Swiss Toggenburg, many British Toggenburgs may have the genetic blueprint of both the British Alpine and the British Goat, the influences of which have helped to improve and enlarge the breed in the past.

Size

Buck132–176 lb (60–80 kg)

Doe119–132 lb (54–60 kg)

Origin & Distribution

The British Toggenburg originated in Britain from stock brought from the Swiss Alps. It is now widely distributed to differing breed standards throughout the Western world and Australasia.

UK

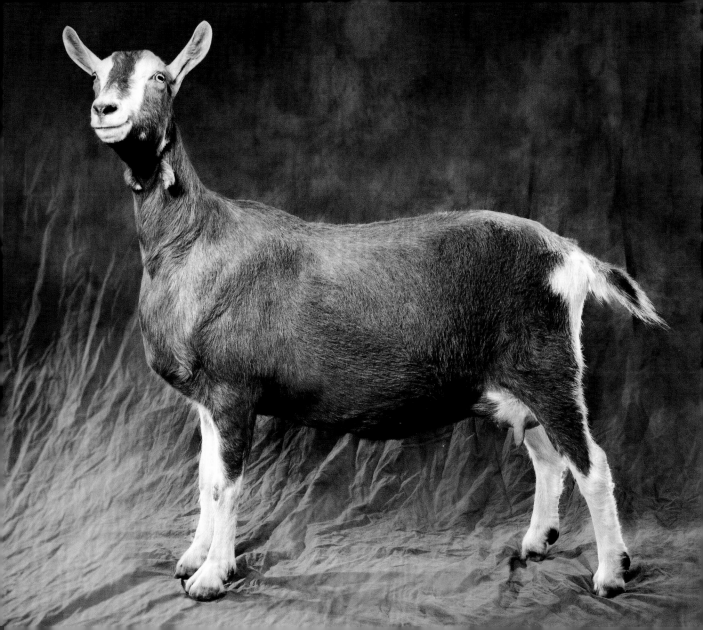

AMERICAN PYGMY

1-YEAR-OLD BUCKLING

The AMERICAN PYGMY goat originated from the West African Dwarf goat. Wider distribution began in the 1960s in the USA, where not only were its domestic attributes recognized but it was also used for experiments by medical establishments. This breed has gained enormous popularity in modern times, for its tractability and attractiveness as well as for its diversity of use.

Features

The color variations for the Pygmy goat are endless and all of them are considered acceptable to the breed standard. It is usual for this goat to have short, stubby horns and the male will often have a long mane. It has a small, cobby stature, and is an adaptable, hardy, and good-natured goat.

Uses

Favored in both the pet and showing world, the American Pygmy was originally bred as a provider of meat and milk although most are not used for this any more. Instead, it is often the breed of choice for driving goat enthusiasts, not least because of its cute appearance. The Pygmy goat is also ideally suited to the small-scale keeping of goats.

Related Breeds

The West African Dwarf, the Congo Dwarf, the Cameroon goat, and the African Pygmy are all known previous breed names of this goat and are still used in those countries. Each country has its own breed standard and often prefixes the name Pygmy with that of their domain.

Size

Buck 33–55 lb (15–25 kg)

Doe 33–55 lb (15–25 kg)

Origin & Distribution

This breed is now known worldwide but its early origins were in West and Central Africa.

Africa

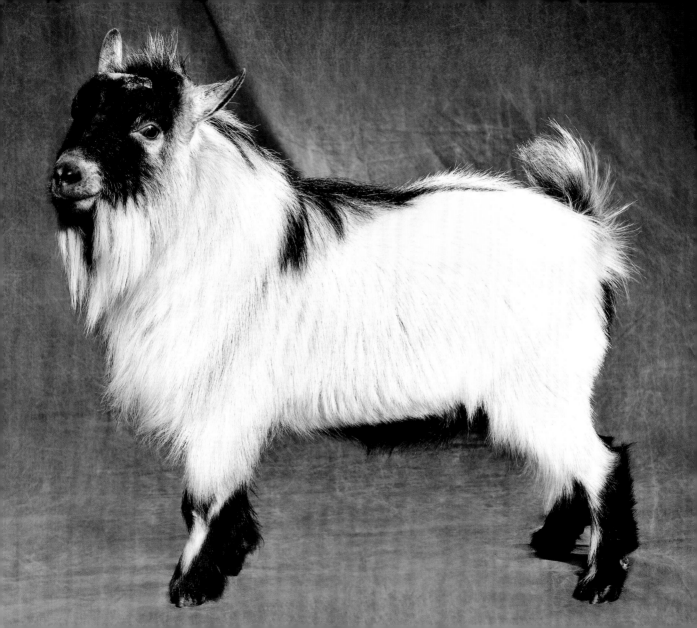

BRITISH FERAL

10-YEAR-OLD DOE

A lthough a FERAL goat is sometimes described as a "scrub" or "bush" goat, there is no doubt that these breeds have often reverted back to their original stock of centuries past and can represent the appearance of original indigenous goats. In the early 20th century, before selective breeding, these goats could be seen ranging the countryside.

Features

The Feral goat can be divided into two types: the Upland and Lowland. The Upland type was a small, lightly built goat able to cope with mountainous terrain. They were short legged and longer coated with either scimitar (sword-like) or twisted horns. The Lowland type was larger and bulkier in build with a shorter coat but still horned, often displaying the wild pattern of coat as seen in the Ibex today, from which all goats have originated.

Uses

Today, depending on the features inherited, this goat may well be used by a homesteader for milk, meat, and skins. In the past, some would have been used as house milking goats and latterly Ferals have been employed to help develop familiar breeds.

Related Breeds

Most goats in the UK will have had some feral influence over the ages.

Size

Buck44–55 lb (20–25 kg)
Doe40–44 lb (18–20 kg)

Origin & Distribution

Undoubtedly, early goats were brought into the UK by both trading and slaver ships traversing the globe. These goats would have bred with earlier imports to produce the feral type. This type of goat is found throughout the world.

UK

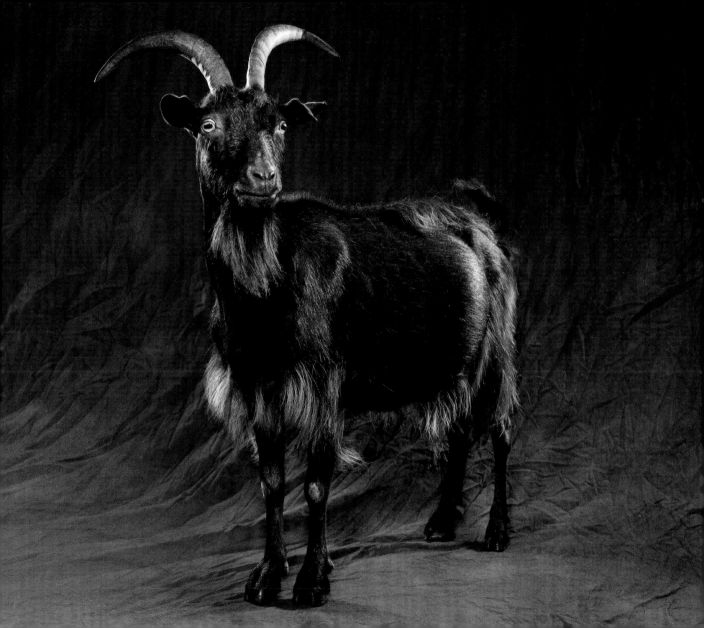

TOGGENBURG

3-YEAR-OLD DOE

The TOGGENBURG was first imported to Britain from France in the late 19th century. It was immediately popular for its milking qualities and its ability to improve the breeding stock. It was the first imported breed to the UK to have its own section in the British Goat Society Herd Book, where it is known as a "closed herd"; that is, to keep the gene pool pure, it can not be graded up.

Features

Medium-brown in color with a range from silver gray to mousey brown, the Toggenburg has white Swiss markings with fine, short hair that sometimes displays fringing at the shoulders, thighs, and mid-line, particularly in the male. Tassels are common but not always present. This goat is mostly polled but horned individuals should have swept-back curved horns.

Uses

The Toggenburg is a classic milking goat that is prized by breeders because its pure gene pool means its numbers are low. An excellent homesteader's goat, it produces an average milk yield of 2,308 lb (1,047 kg) per year, with a 3.55% butterfat content.

Related Breeds

The Toggenburg is a close but smaller cousin of the British Toggenburg. This was derived from crossing the Toggenburg with other Swiss breeds and English goats.

Size

Buck 132–176 lb (60–80 kg)

Doe 121–154 lb (55–70 kg)

Origin & Distribution

The Toggenburg originated in Switzerland and is popular throughout Europe. It was first imported to the UK via Paris in 1884.

Switzerland

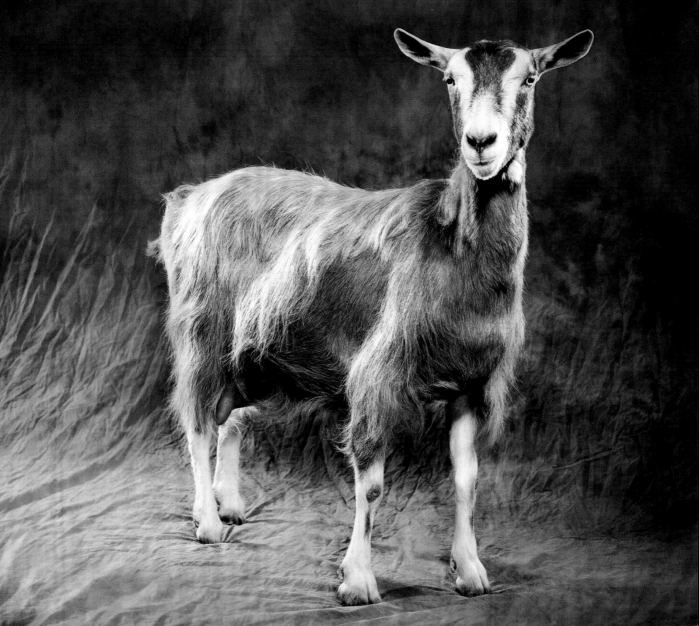

ANGORA

3-YEAR-OLD BUCK

The ANGORA is most famous for its fleece, which is known as mohair. It is shorn twice a year and is prized for producing the "diamond fiber" from which fine materials are produced. White fleeces are the most valued for fiber production but this breed now appears in numerous colors through selective breeding, aimed essentially at the home spinning market.

Features

A petite goat, the Angora has a profusion of wavy fleece with a wool undercoat. Spiral "handlebar" horns are typical of the Turkish and New Zealand types and swept-back curved horns are a feature of the South African type. Flopped ears add to the appeal of this very attractive animal.

Uses

This goat is used mostly for fiber production, and pelts are also used for rug and clothes making. It can also be useful for crossing with dairy breeds to produce a viable meat carcass. The Angora is not used for milk production as it needs the milk to feed its own kids and expends much strength doing so. It grows a prolific fleece throughout the year.

Related Breeds

There are variations of the original stock from Ankara, Turkey; in Australia, New Zealand, South Africa, the USA, and the UK. The Texan Angora is the largest. The Cashgora is another relation, derived from a first cross with any other breed.

Size

Buck 176–220lb (80–100kg)

Doe 70–110 lb (32–50 kg)

Fleece weight 4–11 lb (2–5 kg) twice a year

Origin & Distribution

The Angora remained confined to Ankara, Turkey for many centuries before it was reluctantly exported at the end of the 19th century, leading to its worldwide distribution today.

Turkey

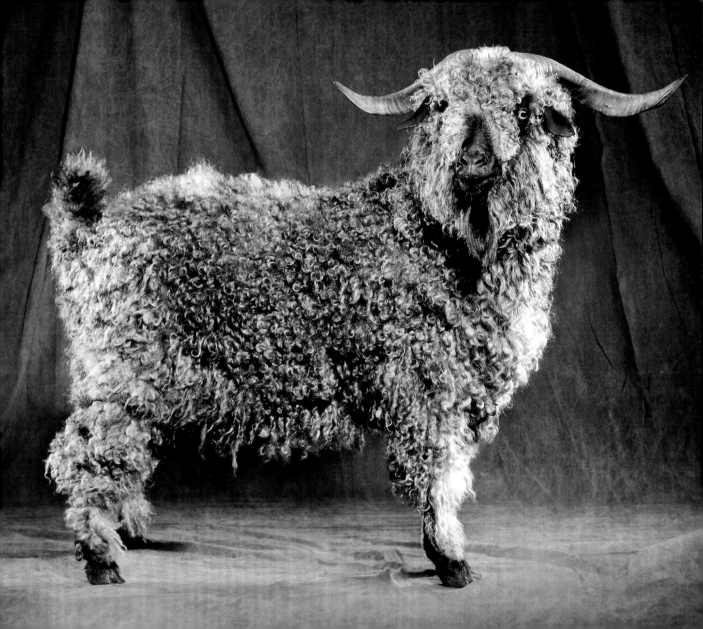

NIGERIAN DWARF

1-YEAR-OLD DOE GOATLING

The NIGERIAN DWARF, also known as the West African Dwarf, is genetically an achondroplastic dwarf, rather than a miniature goat. This is indicated by its disproportionately short legs and a plump, large belly. With a natural resistance to infection by the Tsetse fly, it is a valuable goat in its homeland of West and Central Africa. It was notably exported from Africa in 1870, when the first exhibit appeared in the London Zoological Gardens.

Features

This is a short, stocky goat standing at around 16–20 in (40–50 cm) tall in an assortment of colors. The example shown, although possessing a wonderful color mix, which is desirable in the pet-showing sphere, is perhaps a slightly more elegant example of the breed than that found in its native country. Early maturing, this goat frequently produces "litters" of kids.

Uses

In its native land, the Nigerian Dwarf remains a popular goat for meat and skins rather than milk. In Europe and North America, it has become a popular homesteader's goat, pet, and show animal.

Related Breeds

There are many variations on the dwarf theme, but the closest linked varieties include the Congo Dwarf, Ghana Forest goat, Côte d'Ivoire Dwarf, Kirdi, and Mossi goats.

Size

Buck44–55 lb (20–25 kg)

Doe44–55 lb (20–25 kg)

Origin & Distribution

Originating and still widespread in the coastal regions of West and Central Africa, the Nigerian Dwarf is now found throughout North America, Europe, and the Mediterranean with variants in the Middle East.

Africa

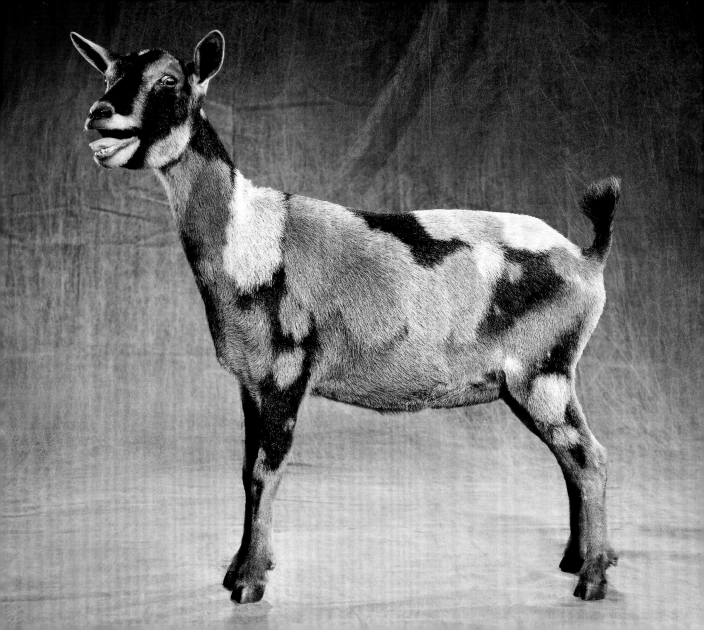

SAANEN
2-YEAR-OLD DOE

The SAANEN is instantly recognizable worldwide as the ultimate commercial dairy goat and brings to mind the stories of Heidi written by Johanna Spyri. This British example will have her roots in imported Dutch stock of the 1920s and those of further Swiss stock, which was imported to the UK in the 1960s. In its native Switzerland, this breed represents 20% of all goats.

Features

The Saanen is a large and capacious dairy goat with a deep body and a short fine coat. It is always white but black spots are permitted according to the breed standard on its ears, udder, and muzzle. Along with the British Saanen, this breed represents the largest group of commercial milking goats in Europe.

Uses

This is a superior milking goat with average milk yields of 2,542 lb (1,153 kg) per year and a butterfat content of 3.81%. It is also a popular homesteader's goat and castrated males are often kept as pets or used as harness goats. It is a useful breed to add size to other dairy breeds.

Related Breeds

Some of the derivatives of the original Swiss Saanen breed are British Saanens, French Saanens, German Improved White, Israeli Saanen, and the Banat White from Romania—all used for commercial milking systems, both stall fed and free range.

Size

Buck 154–198 lb (70–90 kg)
Doe 121–176 lb (55–80 kg)

Origin & Distribution

Originating in northwest Switzerland, the Saanen has influenced breeds throughout Europe and beyond for the past century and continues to do so.

Switzerland

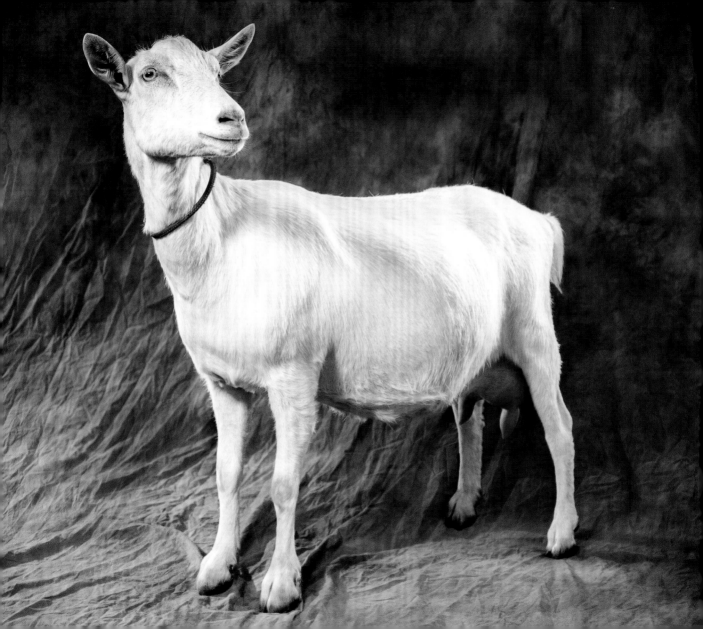

ANGLO-NUBIAN

1-YEAR-OLD DOE GOATLING

The largest of the British dairy breeds, the ANGLO-NUBIAN gained in popularity in the UK in the 1960s when its breed society was formed, even though the breed had been known there for more than a century. Despite its exotic origins, it is well adapted to the temperate climate of Europe and remains a popular choice of dairy goat for keepers today.

Features

This is a large goat with a big voice! It is tall and elegant with low-set lop ears and a Roman nose, although the head itself is quite short. This goat should have a long body and a well-developed udder. Colors range from self-colored to marbled and dappled. The coat is short, hard, and shiny. The Anglo-Nubian is capable of producing an astounding five kids in a litter.

Uses

A prolific milking goat, the Anglo-Nubian produces small but rapidly growing kids of which some males will progress to good meat animals. The annual milk yield is typically 2,200 lb (1,000 kg) with butterfat at 5%.

Related Breeds

Zairaibi goats, with African origins, and the Bricket Cross from Pakistan are both related. In India, Africa, and the Middle East, smaller types of goat like the Anglo-Nubian are common.

Size

Buck 330–441 lb (150–200 kg)

Doe 309–419 lb (140–190 kg)

Origin & Distribution

The Nubian undoubtedly came to the UK via steamers journeying from Africa, India, and the Middle East; the Anglo-Nubian was subsequently developed in the UK. This breed now has a worldwide spread.

UK

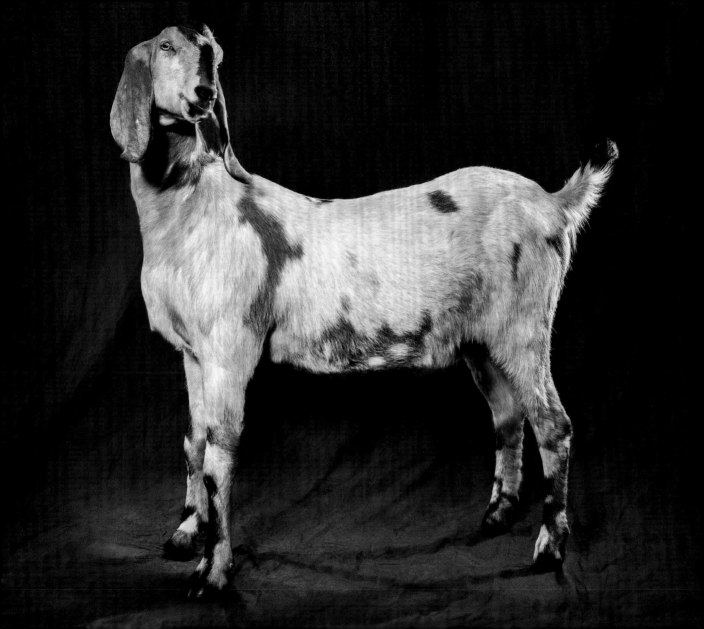

BAGOT

12-YEAR-OLD WETHERED BUCK

One of the rarest breeds of English goats, the BAGOT has "minority" status with only around 500 individuals currently recorded. Its name was derived from the Bagot family who kept a herd in the 14th century. The family crest was a goat head, which can be seen at Bagot's Park in Blithfield, Staffordshire, UK. In 1979, the herd was entrusted to the Rare Breeds Survival Trust.

Features

A small to moderately sized goat with black and white markings and curvaceous horns, which can measure up to 3 ft (1 m) in length. The coat is long and mainly white with a black forequarter and a black bearded head. The Bagot's maternal instincts are somewhat dubious, which perhaps is a clue to their rarity.

Uses

This goat is very much a conservation grazer and is not known for being a productive goat. Today the main emphasis is on maintaining the breed and preventing extinction. Interestingly, there is an old legend that if the Bagot goat becomes extinct then the Bagot family will also die out!

Related Breeds

Genetic connections are uncertain but the Glacier goat of Switzerland known as the Valais is of a very similar type but has a much clearer delineation of color. There is also the Swarzhal of the Rhone region.

Size

Buck	44–55 lb (20–25 kg)
Doe	40–49 lb (18–22 kg)

Origin & Distribution

Lord Bagot suggested in 1934 that this breed, which possibly arrived in the UK with the Crusaders or Normans, may have had Asiatic or Palestinian origins. It is only found in the UK.

UK

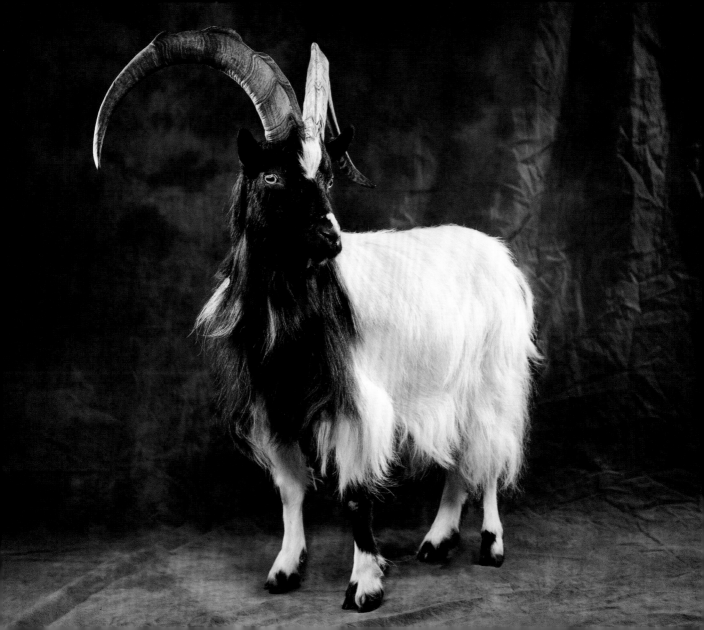

NIGERIAN DWARF
6-MONTH-OLD DOE KID

A small but perfectly formed goat, the Nigerian Dwarf is a miniaturized version of a standard-size goat and has the ability to be a milk and meat provider for a small family with limited space. Its forebears were first imported to the USA from Africa in the late 1950s, and it has now developed there into a distinctive and popular breed.

Features

The diminutive Nigerian Dwarf is a mere 18–20 in (45–50 cm) when mature. It is lightly boned and concave faced with a short, fine coat. Both males and females are generally horned. The variety of colors and unique patterning is one of the breed's attractions. Instead of having traditional brown eyes, this example has blue eyes, which are becoming increasingly desirable among breeders.

Uses

This is an excellent homesteader's goat. It does not require much food but can provide good volumes of milk, averaging 1,102 lb (500 kg) of milk per annual lactation, with a high butterfat content of 6–10%. It has a gentle temperament and is easy to handle.

Related Breeds

This breed is closely related to the Pygmy goat but has been selectively bred to retain a lighter build than the Pygmy. Southern Sudanese goats are widely believed to be the chief contributors to Nigerian Dwarfs.

Size

Buck ..75 lb (34 kg)
Doe ..75 lb (34 kg)

Origin & Distribution

Originating in West and Central Africa, the Nigerian Dwarf is now also found throughout North America, Europe, and the Mediterranean. Variants are found in the Middle East.

Africa

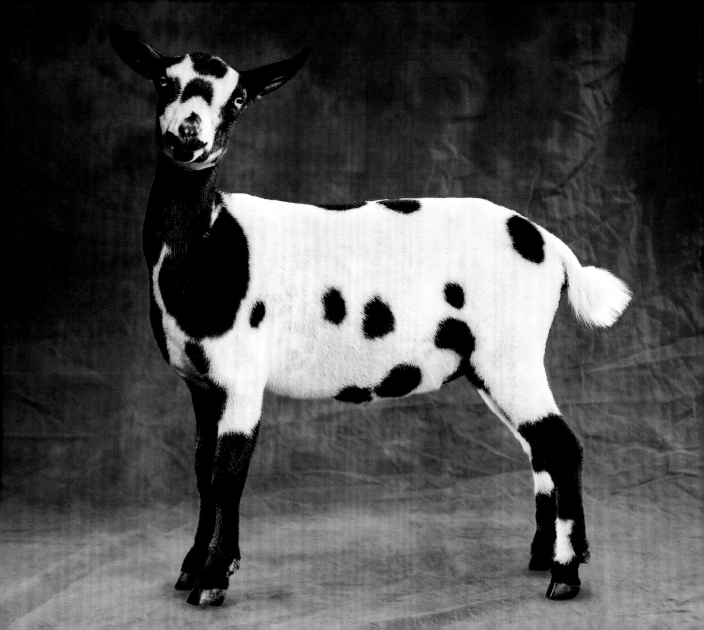

REPORTAGE

Goat fans get ready to enjoy a privileged and rare chance to butt in behind-the-scenes and see all the action at a top breeds show. Wattle you do? Prick up your ears, grab life by both horns, and prepare yourself for a few hairy moments! No kidding about here. This really is show-goat time.

NATIONAL GOAT EXPO

IOWA
UNITED STATES

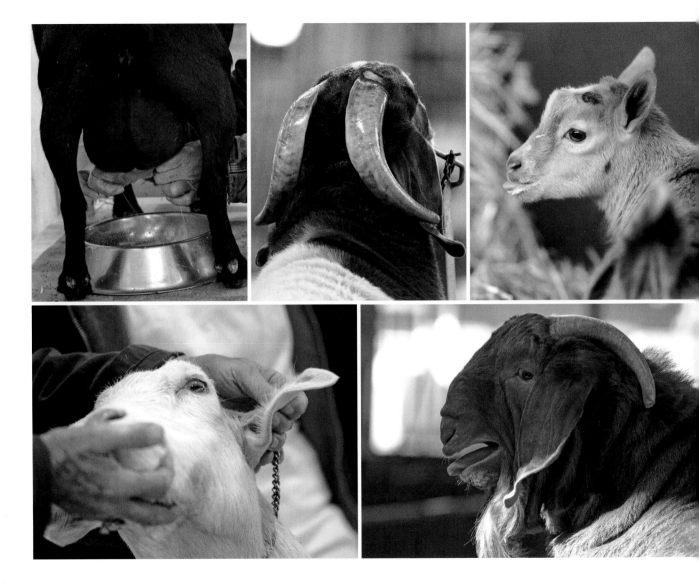

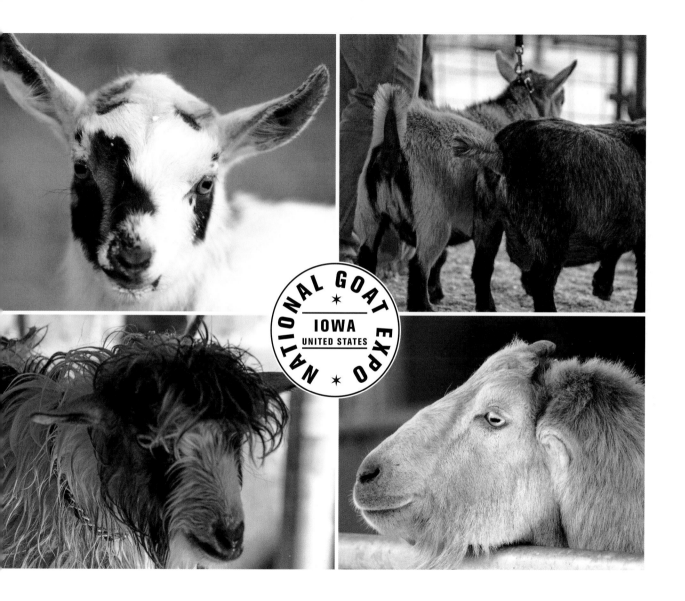

NATIONAL GOAT EXPO
★
IOWA
UNITED STATES
★

BUTTERCUPS GOAT SACTUARY
★ UNITED KINGDOM ★

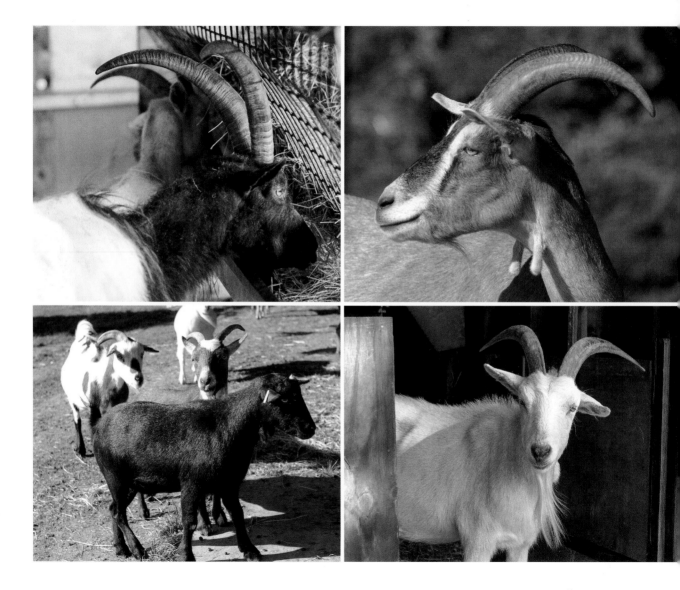

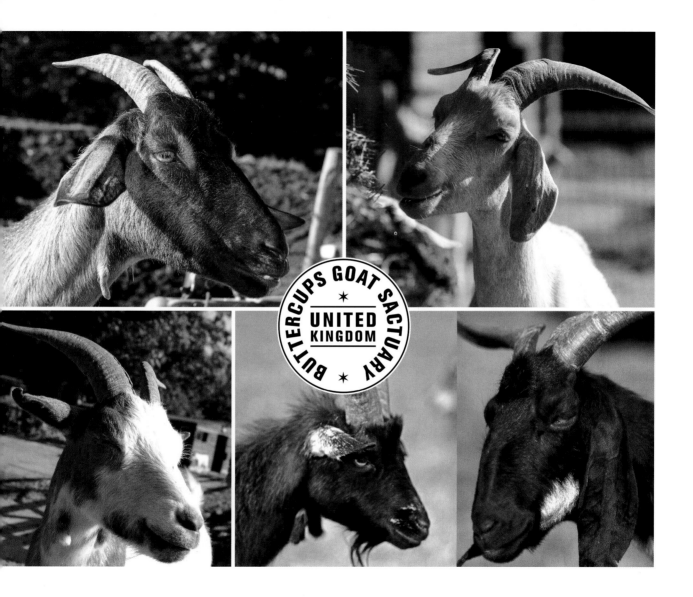

BUTTERCUPS GOAT SACTUARY
UNITED KINGDOM

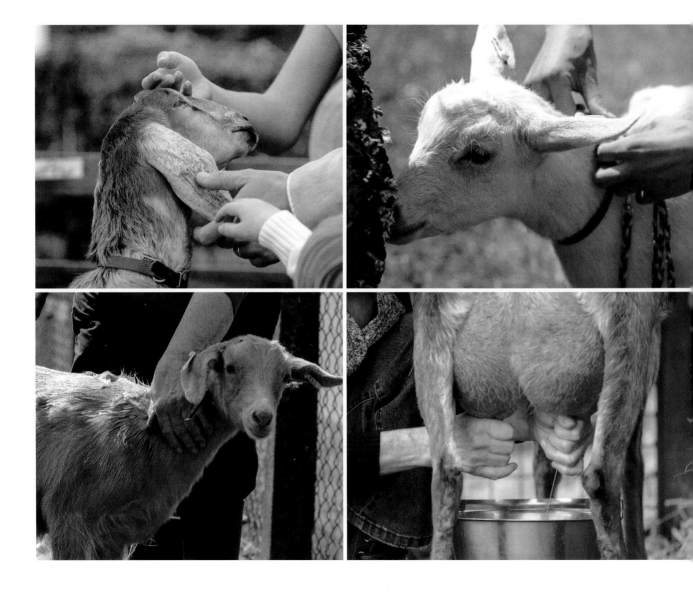

SOUTH OF ENGLAND SHOW
UNITED KINGDOM

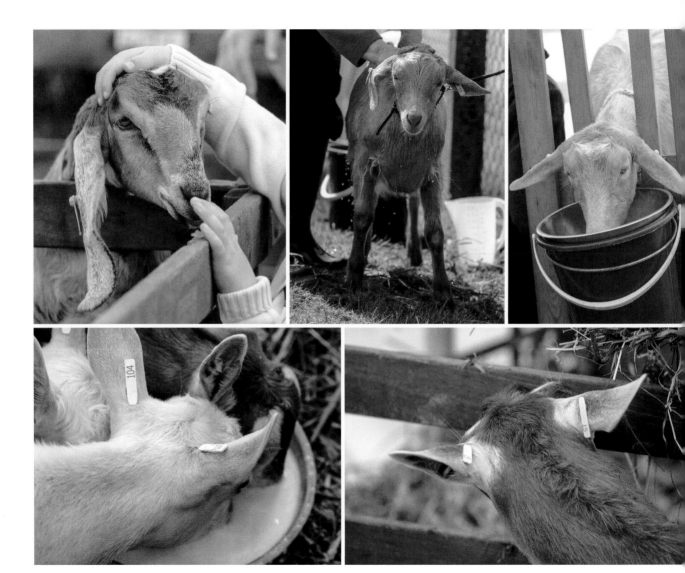

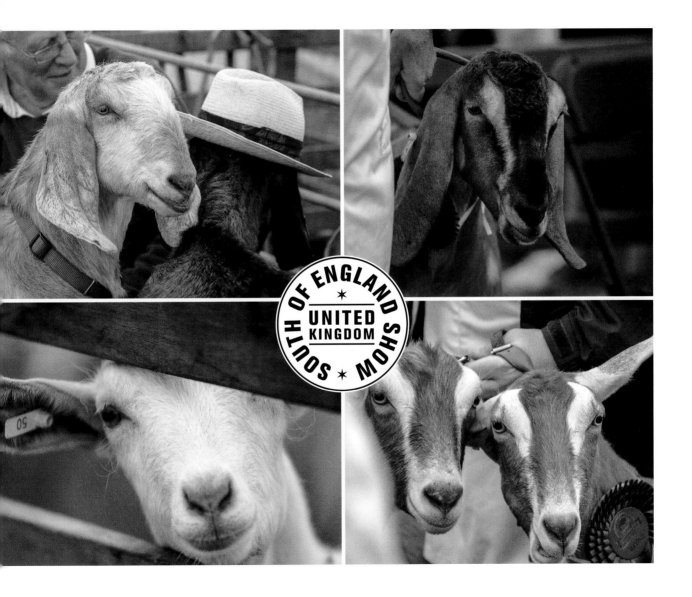

SOUTH OF ENGLAND SHOW

UNITED
KINGDOM

GLOSSARY

Achondroplastic a true genetic dwarfism, characterized by short limbs

Alpine breeds of goat originating in the Swiss, French, Italian, or Austrian Alps—a mountainous region of Europe

Angora breed of goat from Turkey

Annual milk yield the quantity of milk, usually measured by weight in pounds, produced over one year's lactation period

AOV "Any Other Variety"—a term used to describe a mixed-breed goat

Billy goat another name for buck

Breed standard acceptable and typical characteristics for each breed

Buck an entire (uncastrated) male goat

Buckling an entire (uncastrated) goat of between one and two years of age

Cashgora a crossbred goat where one parent is an Angora—typically Angora x dairy goat

Cashmere a goat from Kashmir—also the combed fiber produced from this breed

Conservation grazer a herbivore used to control species of grasses and wild plants in sensitive habitats

Crossbreed any outcross of two or more distinct breeds of goat

Doe an adult female goat

Dominant gene a type of gene that will dominate inherited characteristics

Goatling a female goat of between one and two years of age

Grading up a process of breeding females to pure-bred males of a specific breed for five generations in order to improve milk or fiber yields

Herd book a register held by the national goat society of specific countries to register and recognize specific breeds

Hybrid vigor size and proportion which develops from first crossbreeding

Kid a baby goat up to one year of age

Luster a glistening shine, term used typically to describe mohair

Marbling patterning that emulates the mottled effect of marble

Mid-line a line running down the spine of the animal from poll to tail head

Miniature a very small goat with normal proportions, bred from stock that does not display a dominance of achondroplastic traits

Mohair the shorn fiber of the Angora goat

Nanny goat alternative name for a doe

Nomadic goats that travel with their human carers over large areas

Oberhasli a breed of goat originating in southern Switzerland, also known as the Oberhasli Brienz

Pashmina a Persian word for cashmere from which the shawl-like garment acquired its name

Poll the top of the head between the ears

Polled a naturally hornless goat

Saanen northwest region of Switzerland from which area the goat of the same name originates

Sable descriptive of coat type (dark, luxuriant brown) and the American goat breed

Single lactation the period of time a goat is normally in milk between kiddings—generally eight to ten months

Snowstorm white flecking on the ears of a Nubian goat

Swiss markings a pattern of markings typified by the Swiss breeds. These patterns include head stripes, a white underbelly, and a white undertail

Tassels also known as toggles or wattles. Small, soft hair-covered appendages hanging down from the throat area in Swiss breeds

Toggenburg a breed of goat originating in St. Gallen, northeast Switzerland

Wether a castrated male goat of any age

SHOWS

USA

ADGA National Show (Dairy) Minnesota
www.nationalshow.org

USBGA Show (Boer) Washington
www.usbga.org

American Goat Society Show (location varies)
www.americangoatsociety.com

AFRICA

South African Boer Goat Breeders Association Show
www.boerboksa.co.za

Eastern and Northern Cape Championships
www.boerboksa.co.za

National Boer Goat Show, Pretoria
www.boerboksa.za

AUSTRALIA

Sydney Royal Goat Show
www.sydneyroyal.com.au/goat

BRAZIL

National Sheep and Goat Show Jaao Pessoa
www.iga-goatworld.com

CANADA

Expo Boer Goat Show, Quebec

Western Canada Goat Show, Saskatchewan

Canadian Goat Society Show, British Columbia

Visit: www.goats.ca for details of these and other events.

NEW ZEALAND

Royal A & P Society Affiliated Shows
www.ras.org.nz

UK

National Breed Show, Newark, Nottinghamshire
www.britishgoatsociety.com

Devon County Show
www.devoncountyshow.co.uk

Dorset County Show
www.dorsetcountyshow.co.uk

East of England Show
www.eastofengland.org.uk

Great Yorkshire Show
www.yas.co.uk

Kent County Show
www.kentshowground.co.uk

Rare Breeds Show, Singleton, West Sussex
www.wealddown.co.uk

Royal Berkshire Show
www.newburyshowground.co.uk

Royal Bath and West Show
www.bathandwest.com

Royal Cornwall Show
www.royalcornwallshow.org

Royal Norfolk Show
www.royalnorfolkshow.co.uk

Royal Welsh Show
www.rwas.co.uk

South of England Show
www.seas.org.uk

Stithians Show (Cornwall)
www.stithiansshow.org.uk

ASSOCIATIONS

All links to shows are available on the following websites:

USA

American Goat Society
www.americangoatsociety.com

American Dairy Goat Association
www.adga.org

American Nigora Goat Breeders Association
www.nigoragoats.homestead.com

American Nigerian Dwarf Dairy Goat Association
www.andda.org

International Sable Breeders Association
www.sabledairygoats.com

Oberhasli Goat Club
www.oberhasli.us

International Fainting (Myotonic) Goat Association
www.faintinggoat.com

American La Mancha Club
www.lamancha.com

UK

The British Goat Society
www.britishgoatsociety.com

The Rare Breeds Survival Trust
www.rbst.org.uk

The Pygmy Goat Society
www.pygmygoatclub.org

Angora Goat Society
www.angoragoats.com

Bagot Goat Society
www.bagotgoats.co.uk

The Golden Guernsey Goat Society
www.goldenguernseygoat.org.uk

The Anglo Nubian Goat Society
www.anglonubiangoatsociety.com

The Saanen Goat Society
www.saanen.co.uk

The British Toggenburg Goat Society
www.britishtoggenburgs.co.uk

NEW ZEALAND
New Zealand Dairy Goat Breeders Association
www.nzdgba.co.nz

AUSTRALIA
Dairy Goat Society of Australia Ltd
www.dairygoats.org.au

Australian Cashmere Growers Association
www.australiancashmere.com.au

EUROPE
European Boer Goat Association (UK based)
www.boergoats.com

INTERNATIONAL
International Goat Association
www.iga-goatworld.com

International Nubian Breeders Association
www.i-n-b-a.org

REFERENCES & CREDITS

World Dictionary of Livestock, 4th edition, Ian Mason (1996), Cabi Publishing, Oxfordshire

Goats of the World, Valerie Porter (1996), Farming Press, Ipswich

Raising Goats for Meat, Dairy & Fiber, Felicity Stockwell (2009), Good Life Press, Preston

Pictures on pages 7 to 12 are courtesy of Shutterstock.

ACKNOWLEDGMENTS

I would like to thank the following people and societies:

Miss Miriam Milburn, for fostering my interest in goats on the island of Guernsey all those years ago.

The Woolwich Building Society, who funded the purchase of my first goat in 1972.

Liz Wright and *Smallholder* magazine, for supporting my writing for so many years.

The British Goat Society.

Goats and goat keepers in my life, who have inspired me.

And thanks also to the businesses and restaurants who have supported my commercial goat products over the years and the Dairy Hygiene Inspectorate who trusted me to manufacture and sell unpasteurized goats' milk, yogurt, and cheeses.

PUBLISHER'S ACKNOWLEDGMENTS

We would like to thank Jen Parrish from the National Goat Expo, Bob and Valerie Hitch from Buttercups Sanctuary for Goats (www.buttercups.org.uk), Isabel Gander and Barbara Ruth from the South of England Agricultural Society (www.seas.org.uk), and Ros Earthy from The British Goat Society (www.britishgoatsociety.com).

We would also like to thank all of the following goat owners and breeders who allowed us to photograph their goats for this book:

British Guernsey Anita Tydeman
Pygmy Jill Conklin
Mini Lamancha Norman W. Geiser
Nubian Jennifer Seffron
Angora Bob and Valerie Hitch
Miniature Alpine Andrea Green
Golden Guernsey Anita Tydeman
British Toggenburg Bob and Valerie Hitch
Angora Mary Stone
British Saanen Nick Parr

Boer Glen and Nancy Casada
Pygmy Bob and Valerie Hitch
Boer Cross James Agnew and Brenda Larner
AOV Doubleday and Smith
Saanen Bob and Valerie Hitch
African Pygmy Jill Conklin
Sable Tim Flickinger
Anglo-Nubian Mr and Mrs P.J. Radford
Myotonic Mini Silky Grace Davidson
British Feral Bob and Valerie Hitch
Nygora Marty Murphy
Boer Boers by Hobby
Mini Silky Linda Bourque and Mindy Smith
Myotonic Grace Davidson
Mini Oberhasli Andrea Green
Cashmere Bob and Valerie Hitch
Cashmere Alexander
British Alpine Bob and Valerie Hitch
Nigerian Dwarf David Price
Anglo-Nubian Bob and Valerie Hitch
British Toggenburg Mrs. B. Ruth
American Pygmy Susan Neal
British Feral Bob and Valerie Hitch
Toggenburg Teigh O'Neill
Angora Marty Murphy
Nigerian Dwarf Jan Nelson
Saanen Doubleday and Smith
Anglo-Nubian Erica and Ian Churchill
Bagot Bob and Valerie Hitch
Nigerian Dwarf Carol Baldwin

INDEX

A

Abyssinian *see* Nubian
African Pygmy 46, 47
Alpine breeds 7, 26
 British Alpine 70, 71
 Miniature Alpine 26, 27
Alpine Ibex 12
American Pygmy 78, 79
Anglo-Nubian 50, 51, 74, 75, 90, 91
Angora 7, 10, 24, 25, 32, 33, 84, 85
AOV (Any Other Variety) 13, 42, 43
Arabian Najdi 7
art 8

B

Bagot 12, 92, 93
Bayliss, Frank 60
"Bill the Goat" 8
Boer 7, 9, 36, 37, 58, 59
Boer Cross 40, 41
breed standards 13
British Alpine 70, 71
British Feral 54, 55, 80, 81
British Guernsey 16, 17
British Saanen 12, 34, 35
British Toggenburg 30, 31, 76, 77
"Burgan" 7

C

Cashmere 10, 66, 67, 68, 69
chamois leather 10
cheese 9
China 8
competitions 13
cultural significance 8

D

dairy 7, 9, 11, 12
diet 8, 12
domestication 7, 8
driving 11

E

endangered breeds 12

F

Fainting Goat *see* Myotonic
feral goats
 Bagot 12
 British Feral 54, 55, 80, 81
fiber 7, 10
 cashmere 10, 68
 mohair 7, 10, 24, 32, 84
fleeces 7, 10
food production *see* meat; milk

G

Golden Guernsey 12, 28, 29
grooming 13

H

history 8
hooves 9, 13
horn 9

I

Ibex 12
Indian *see* Nubian
intelligence 7, 8

J

Japan 8

K

Kashmir *see* Cashmere
kid leather 10

L

leather 10

M

meat 7, 8, 9
Milbourne, Miriam 28

milk 7, 9, 11, 12
 competitions 13
Mini Lamancha 20, 21
Mini Oberhasli 64, 65
Mini Silky 60, 61
Miniature Alpine 26, 27
mohair 7, 10, 24, 32, 84
"Mongolian lamb" 10
Myotonic 62, 63
Myotonic Mini Silky 52, 53

N

Nigerian Dwarf 72, 73, 86, 87, 94, 95
nomadic cultures 9, 10
Nubian 22, 23
 Anglo-Nubian 50, 51, 74, 75, 90,
 91
Nygora 56, 57

O

old UK breeds 12
Orr, Renee 60

P

Perris, Andrew 7
pets 7, 11
Pygmy 11, 18, 19, 38, 39
 African Pygmy 46, 47
 American Pygmy 78, 79

Q

Queen Victoria 8

R

rare breeds 12
recreational uses 11
regimental goats 8
religion 8

S

Saanen 12, 44, 45, 88, 89
 British Saanen 12, 34, 35
Sable 48, 49
Scandinavia 8
Shah of Persia 8
showing 7, 11, 13, 96–109
skins 7, 9, 10
symbolism 8

T

Taiwan 8
textiles 10
Tinsley, John 52
Toggenburg 82, 83
 British Toggenburg 30, 31, 76, 77

W

West African Dwarf *see* Nigerian
 Dwarf
"William Windsor" 8
wool *see* fiber

Z

zodiac 8